achieving depth & distance
painting landscapes in oils

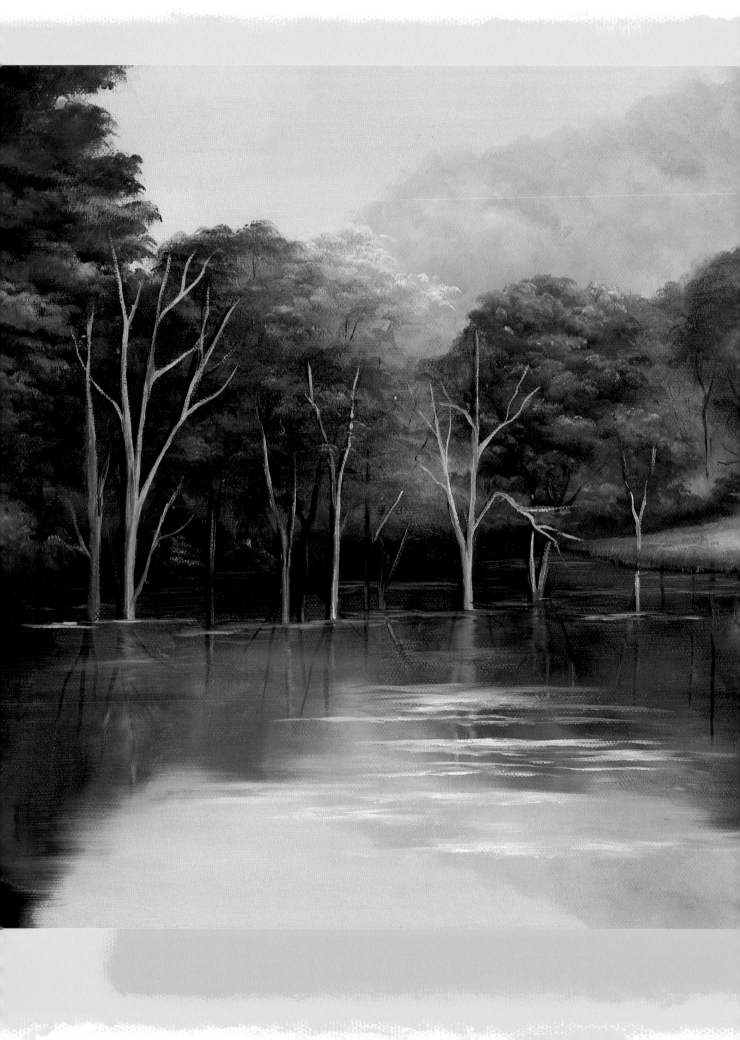

achieving
depth &
distance

painting
landscapes
in oils

Kitty Gorrell

NORTH LIGHT BOOKS
CINCINNATI, OHIO
www.mycraftivity.com

www.fwpublications.com

Other fine North Light Books are available from your local bookstore, art supply store or direct from the publisher.

12 11 10 09 08 5 4 3 2 1

Distributed in Canada by Fraser Direct
100 Armstrong Avenue
Georgetown, ON, Canada L7G 5S4
Tel: (905) 877-4411

Distributed in the U.K. and Europe by David & Charles
Brunel House, Newton Abbot, Devon, TQ12 4PU, England
Tel: (+44) 1626 323200, Fax: (+44) 1626 323319
Email: postmaster@davidandcharles.co.uk

Distributed in Australia by Capricorn Link
P.O. Box 704, S. Windsor NSW, 2756 Australia
Tel: (02) 4577-3555

Library of Congress Cataloging-in-Publication Data

Gorrell, Kitty.
 Achieving depth & distance: painting landscapes in oils. /
Kitty Gorrell.—1st ed.
 p. cm.
 Includes index.
 ISBN 978-1-60061-024-0 (pbk. : alk. paper)
 1. Landscape painting—Technique. 2. Perspective. I. Title.
II. Title: Achieving depth and distance.
ND1342.G67 2008
751.45'436—dc22

2007049762

Edited by Kathy Kipp
Cover designed by Clare Finney
Designed by Wendy Dunning
Production coordinated by Greg Nock
Photographed by Christine Polomsky

METRIC CONVERSION CHART

To convert	to	multiply by
Inches	Centimeters	2.54
Centimeters	Inches	0.4
Feet	Centimeters	30.5
Centimeters	Feet	0.03
Yards	Meters	0.9
Meters	Yards	1.1

ABOUT THE AUTHOR

Kitty Gorrell began studying art seriously as a young adult and her creative drive has taken her from a determined beginner to an active professional artist specializing in subjects drawn from nature and her heritage. Following 20 years in business, Kitty closed her River Front Gallery in 2004 and today works as an independent artist, instructor, author and promoter of the arts. In 2006, the West Virginia Division of Culture and History presented Kitty with the "Order of the Arts and Historical Letters" award in recognition of outstanding service in the performing or fine arts in West Virginia. Her newly constructed Kitty Gorrell Studio for Creative Studies opened for classes in autumn 2007. Kitty also hosts "Homecoming Hues, A Painting Retreat" every September in central West Virginia. Kitty's website, www.KittyGorrell.com, includes examples of her work and her schedule of classes and seminars, as well as materials for purchase to assist in art and framing.

ACKNOWLEDGMENTS

Kathy Kipp, my editor, and the rest of the staff at North Light Books have been wonderful to work with and I sincerely thank Kathy for "watching my work" and the invitation to write this book. She has been a joy to work with and I appreciate her help and support immensely.

My earliest memory of creative art was as a child attending a small rural school. We were very fortunate that our teacher knew the value of art and included it in our education. I remember clearly the feeling of pride when Miss Houseman praised my work in front of the whole school! I hope that I have given that same sense of pride to students in my classrooms and seminars over the years.

An individual who was a wonderful inspiration to me is the late Kathleen Ruttencutter. Kathleen was a beautiful artist who constantly encouraged and challenged me to put feeling and passion in my paintings and to paint the world that I know best. I have studied privately and at select locations across the country with several outstanding teachers. Each teacher affected my abilities and helped me form the techniques and palette I use today. Most influential of these teachers were Bill Alexander for the spirit he shared with so many, Robert Warren for his use of color and technique, Dalhart Windburg for his acknowledgment of my work, and Buck Paulson for his inspiration. In addition I would like to thank Dorothy Dent for the art and friendship we have shared for many years.

DEDICATION

I dedicate this book first to my husband, Chuck, and our sons, Rob, Randy, David and Steve. They are my primary support and have always been there for me and the many artistic projects we have completed over the years. In addition they helped me find the *time* to follow my dreams in painting. Thank you, guys! I also dedicate this book to the many students and friends who have attended my classes and seminars over the years. Your dedication inspired and challenged me to continue my art education as well. It is a great pleasure for me to share with you the things that I have learned through time, wonderful teachers and life itself.

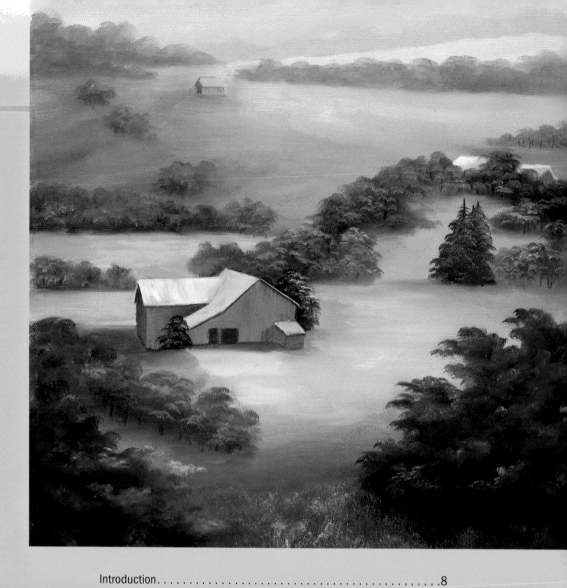

contents

Introduction .8

MATERIALS

Paints and Brushes .10

Preparation and Underpainting with Acrylic Paint12

Mediums and Other Fluids .12

How to Make Your Own Clear Base Medium12

Other Supplies .12

Setting Up Your Oil Color Palette .14

Measuring a "Bead" of Paint .14

Chart of Oil Colors Used .15

OIL PAINTING TIPS & TECHNIQUES

Loading a Filbert Brush with Paint .16

Picking Up a "Scoop" of Paint .17

"Lean" versus "Fat" Amount of Paint .17

Painting Foliage with the "Neutral Stroke"18

Scrubbing versus Blotting .19

Using a Mop Brush and a Fan Brush .19

Applying Clear Medium to the Canvas .20

Using "Less-than-Ideal" Reference Photos21

10 LESSONS: ACHIEVING DEPTH AND DISTANCE IN LANDSCAPES

Demonstration 1: "Sunset Sky" .22
 Lesson: You can still achieve the feeling of distance even
 with vibrant colors—just alter their form.

Demonstration 2: "Winter's Blanket" .30
 Lesson: Detail fades away in far distant trees, contrasting
 with sharp detail in foreground trees.

Demonstration 3: "Spring Creek" .40
 Lesson: The more detail in your mid-ground area, the closer
 it appears. Details always bring an area or object forward.

Demonstration 4: "Water Colors" .50
 Lesson: Intense fall colors in the mid-ground are muted only
 slightly in foreground reflective water.

Demonstration 5: "Valley Farmland" .64
 Lesson: You can achieve a complete range of depth even
 from a high point of view looking down into a valley.

Demonstration 6: "High Valley Summer" .78
 Lesson: To keep large, dominant objects like mountains in
 the far distant background, their value should be very close
 to the sky's value.

Demonstration 7: "Ocean View" .90
 Lesson: Clouds that lay low to the horizon line make it
 appear even more distant.

Demonstration 8: "Rolling Hills" .102
 Lesson: Tree-covered hills in the foreground, mid-ground
 and distance are not all the same green. Colors become
 duller and grayer the further away they are.

Demonstration 9: "On a Clear Day" .116
 Lesson: Fall foliage is as bright in the mid-ground as it is
 close up, but the haze of distance mutes the colors.

Demonstration 10: "Willow Pool" .132
 Lesson: Keep the foliage of foreground trees open and airy
 so the far distant background can be seen through it.

Resources .142
Index .143

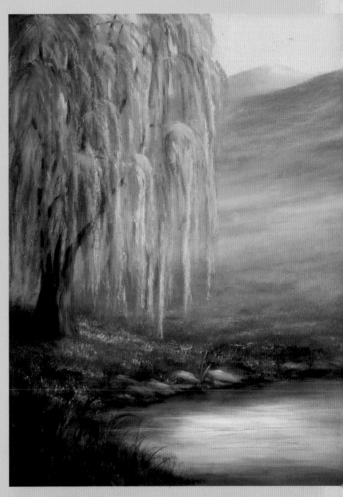

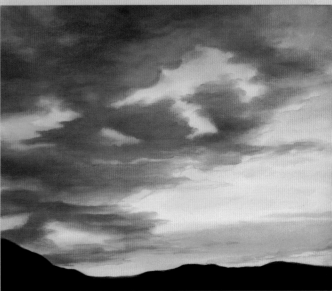

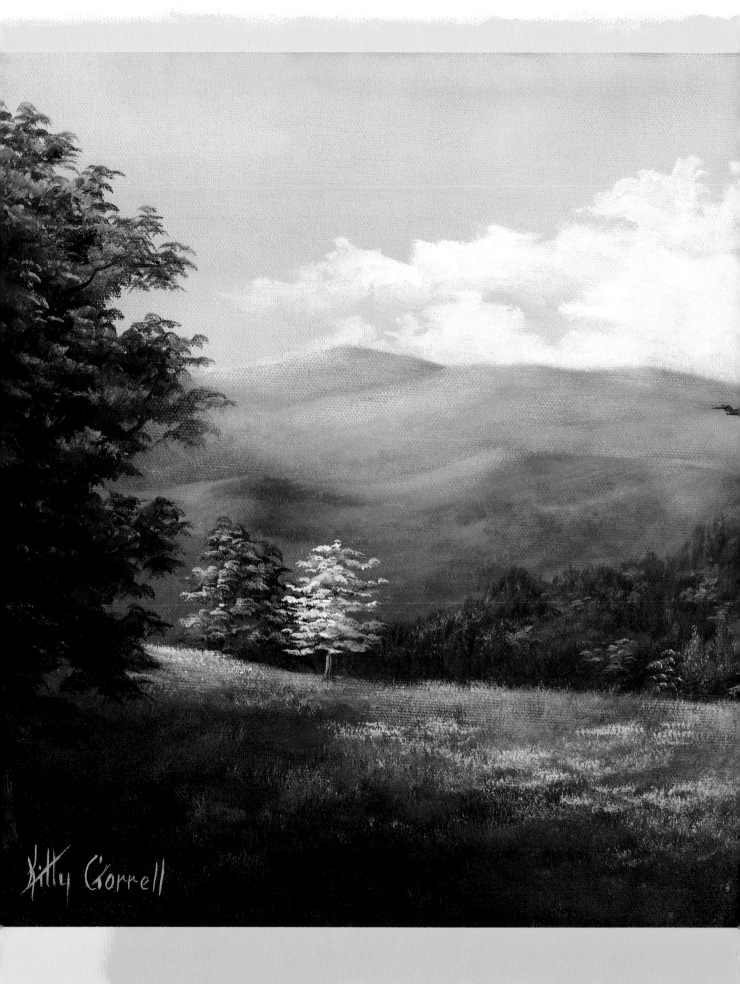

To capture the beauty of nature in all its wonders is an exciting challenge for painters of all kinds from beginners to professionals and everyone in between. A new scene is available at every turn, anywhere in the world, so the possibilities are limitless. As I prepared the paintings for this book, I chose scenes that I felt would allow me to demonstrate the use of perspective, color, values, temperature and form to establish the depth of field necessary for a successful landscape painting.

Each painting in this book focuses on a specific lesson on how to achieve the illusion of depth and distance on the flat plane of the canvas. This general concept can be summarized into one important statement:

The colors and values of each scene soften as the distance increases, as well as the size and clarity of the subjects.

Even though you know two subjects may be the same size and color when they're side by side, if you place one of them into the background in your painting, it will decrease in size, value and detail as it recedes into the distance. Therefore when you are painting a landscape, it is vital to observe carefully and paint what you see, not what you know.

I work primarily from photographs I have taken at various locations around the country and enjoy the challenge of developing paintings from those photos. However, if you've ever been disappointed in some of your vacation photos after you've returned home, you'll know that not every photo is ideal to use as the basis for a painting. Turn to page 21 to see a great example of what I mean. With a little tweaking and some creativity, I turned a problematic photo into a lovely little landscape!

I also work from a fairly limited palette of oil colors, whether in the studio or on location, and I mix a range of colors from that limited palette to fulfill the needs of the individual painting. You'll see how this is done in each of the painting demonstrations in this book.

Realistic foliage can be achieved quickly and easily using my "neutral stroke" shown on page 18, and with just a little practice you can use this stroke for just about any deciduous or evergreen tree or shrub.

I hope you'll enjoy re-creating each landscape demonstration in this book and will incorporate each demo's lessons into your own compositions. And I encourage you to follow your passion and paint the beauty that Mother Nature has surrounded us with so abundantly!

Materials

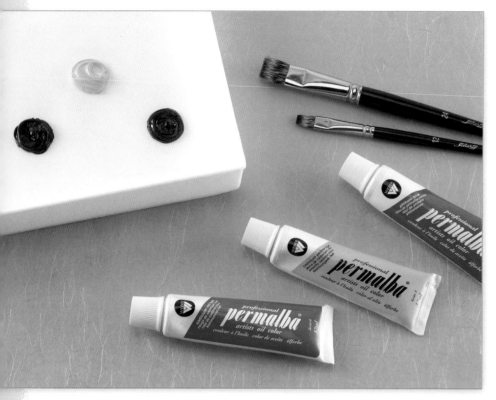

2. Scharff Classic Filbert and Flat Brushes

I use these badger-hair brushes extensively for all foliage, flowers and detail work throughout my paintings. A high-quality blend of natural hairs, these brushes maintain the shape and control needed for painting in oils. The filbert brushes are especially beneficial for the "neutral stroke" I used to paint all of the foliage in this book. Pictured are the nos. 4 and 8 filberts, and the nos. 4, 12 and 24 flats.

3. Permalba Bristle Brushes

For blocking in color and large surface areas on my canvas, I prefer a white, stiff-bristle flat brush such as the Permalba Bristle Brushes from Martin/F. Weber. These long-handled brushes give me the control I need to distribute the paints throughout the painting with a minimum of effort while at the same time leaving a soft blended look with very little texture. Shown here are the nos. 8 and 10 flats.

4. Mop or Hake Brush

This large, soft brush is ideal for softly blending brushstrokes and textures on your canvas.

5. Synthetic Flat Brush

This is a ¼-inch (6mm) or no. 6 flat with synthetic bristles that I use to apply black gesso for dark values.

6. Script Liner

I use a long-handled no. 2 script liner to paint small tree branches, grasses and fine details. A synthetic or natural hair will work for this brush, but it needs to have the bristle-length of a script brush.

7. Palette Knife

A good palette knife is needed for mixing colors in preparation for your painting. I prefer a flexible tapered knife with a trowel-style handle and a smooth metal blade.

8. Fan Brush

A no. 3 bristle fan brush is used to paint the foliage on the willow tree in the "Willow Pool" project in this book. It can also be used for grass textures.

9. Craft Brush

I use a 2-inch (51mm) soft bristle craft brush to apply clear medium to my canvas prior to painting with oils.

PAINTS

Permalba Professional Oils For all the paintings in this book, I used Permalba Oil Paints from Martin/F. Weber. They are professional grade paints that come in tubes and are available at your local art and craft supply store. Permalba oils are made from densely concentrated pigments, which give you a consistent strength and allow for beautifully blended colors and superior covering power. The colors I used for each painting in this book are measured as a full bead of paint as it is squeezed from the tube (see page 14 for a demonstration of a full bead of paint). If you are using an alternative brand of paint, please note that the formulas given for the premixed colors will need to be adjusted to compensate for the difference in pigment strength.

BRUSHES

1. Foam Brush These inexpensive, 2-inch (51mm) foam brushes are used to apply orange acrylic paint as a basecoat to the canvas prior to painting with oils.

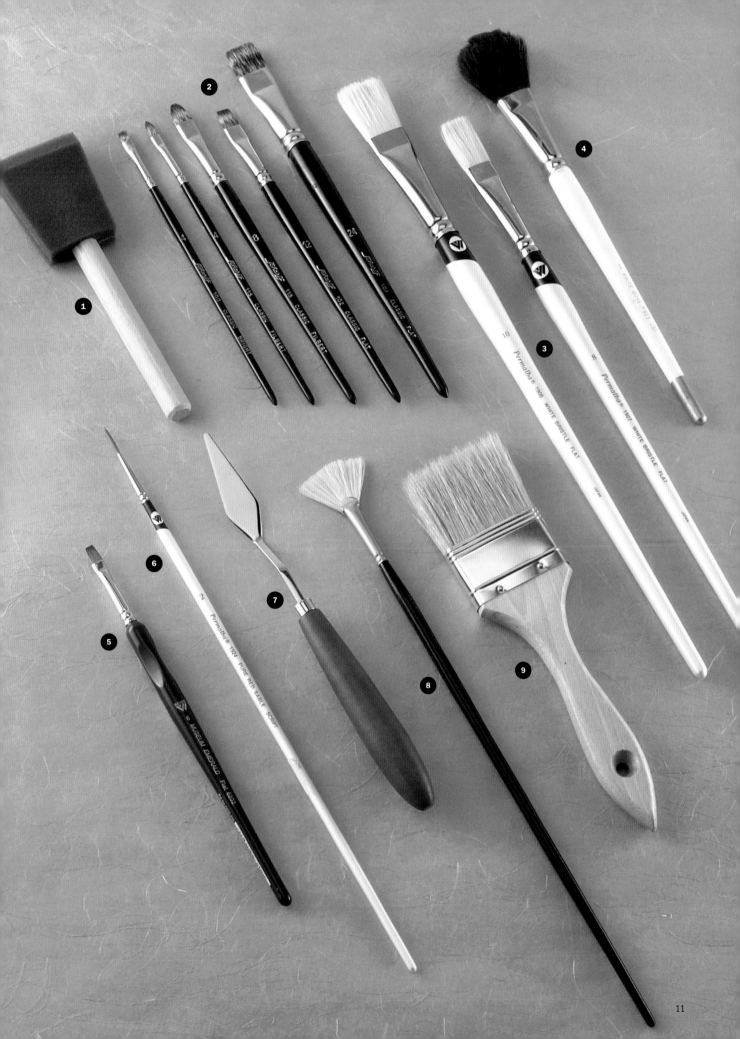

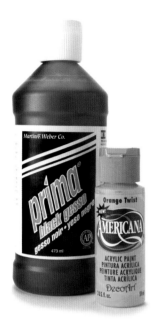

Prima Black Gesso and Orange Twist Acrylic

PREPARATION AND UNDERPAINTING

Prima Black Gesso This black gesso works extremely well when I need to set a dark value in place before I begin my actual oil painting. It has a good creamy consistency that glides smoothly from the brush, with an open time long enough to get the painted work completed without rushing. Any use of the black gesso must be completed before the clear medium is brushed onto the canvas.

Orange Twist Acrylic Paint I use this pure orange bottled acrylic paint, made by DecoArt Americana, for some of my canvas paintings where I need a warm tone as the base for the oil painting to follow. I apply an even coat over the entire canvas with a 2-inch (51mm) foam brush and allow it to dry thoroughly before proceeding to the oils.

MEDIUMS AND OTHER FLUIDS

Clear Medium Mix Prior to painting, I often cover my entire canvas with a thin coat of clear medium, which creates a workable surface for applying and blending the oil colors. I prefer to use my own clear medium, which I blend in my studio from equal parts of Artist's Safflower Oil, Alkyd-Gel, and odorless Turpenoid. Here's how to make it: In a small, clear container with straight sides to assure accurate measurements, add equal parts of the odorless Turpenoid first, followed by the alkyd gel. Cover with a tight lid and shake the container gently until the gel is dissolved. Add an equal part of the Artist's Safflower Oil to the container, cover tightly and shake gently until completely blended to create the finished clear medium. This medium can also be used as a glazing medium or added sparingly to oil paints as a thinning agent or to make them more transparent.

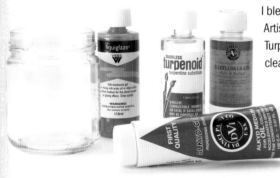

A mixing jar, Liquiglaze, Turpenoid, Safflower Oil, and Alkyd-Gel.

Turpenoid I use this artist-quality odorless turpentine substitute to make my own clear medium as described above. It is also excellent as a solvent for cleaning paint brushes and for removing spots of paint from clothing.

Alkyd-Gel Alkyd-Gel is the drying agent I use to make my own clear medium as described above. It can also be added to individual tube oil colors to make the colors more transparent and to speed the drying time.

Safflower Oil Artist's Safflower Oil is the third ingredient in my clear medium mix. I use Artist's Safflower Oil instead of linseed oil to help eliminate yellowing and to aid in the drying time. If you have difficulty finding Artist's Safflower Oil, you could substitute a safflower oil from your local supermarket, but that variety will not dry as quickly, is not quite as refined, and could cause yellowing.

Liquiglaze Liquiglaze by Martin/F. Weber is a soft, translucent, bottled gel that I sometimes use as a medium when I need a faster drying time than the clear medium gives. I brush-mix Liquiglaze into my working color as I progress through the painting to control the drying time of my oils rather than adding it to the mounds of paint on my palette. A substitute could be Liquin by Winsor & Newton, which also works well but has a stronger odor.

SUPPLIES

Stretched Canvas Each painting in this book is painted on either an 11 x 14-inch (27.9cm x 35.6cm) or a 12 x 16-inch (30.5cm x 40.6cm) stretched canvas. Choose a canvas with a medium-to-smooth tooth and a very white primer.

Easel I strongly recommend the use of an easel, either a floor easel or a tabletop, any time you are painting on canvas. This keeps your hands free but more importantly it keeps the canvas at the proper angle for painting, and gives the correct perspective of the scene or landscape being painted.

Palette I prefer a disposable multi-palette, 12 x 16-inch (30.5cm x 40.6cm), acceptable for either oils or acrylics. You need a palette of this size to accommodate the number of tube colors required in addition to the color mixes needed to complete each painting.

Disposable palettes come in tablet form and are available at any art or craft supply store.

Palette Keeper This is a large, flat airtight container that holds your disposable palette. It allows you to save your paints and color mixes for several days and to transport your palette safely from one location to another. I prefer the Masterson Palette Seal. Palette keepers are available at many art and craft supply stores.

Tracing Paper This is a semi-transparent paper used to trace the line drawings from this book and transfer them to your canvas using gray graphite paper. Use a red pen when tracing the drawing to help you see that you have traced over all necessary lines. Tape your tracing-paper line drawing to your canvas with masking tape tabs along the top to keep it in place while you are transferring the drawing to the canvas.

Gray Graphite Paper You'll be using this to transfer the line drawings in this book to your prepared canvas. Place the graphite paper between the traced drawing and your canvas. Trace over your line drawing with enough pressure to allow the design to show up clearly on the canvas.

Paper Towels Keep a stack of folded paper towels, such as Bounty, next to your palette so you can wipe excess paint from your brush.

KG Kanvas Karrier This is a specially designed and unique carrier for transporting and storing wet oil paintings. The copyrighted insert creates space between your painting surface and the lid, and keeps the canvas from shifting side to side while in motion. (See the Resources page in the back of this book for information on where to buy.)

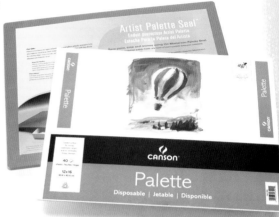

Palette keeper and palette paper

Tracing paper and graphite paper

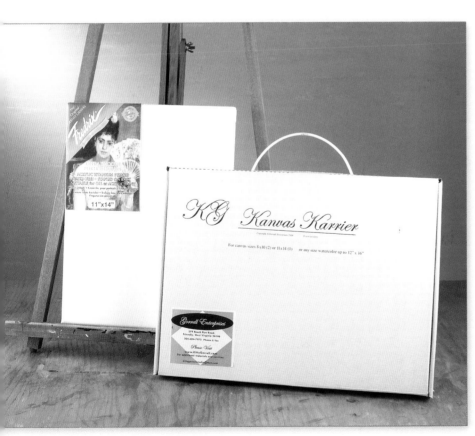

Stretched canvas, tabletop easel and cardboard canvas carrier for transporting wet paintings.

Setting Up Your Oil Color Palette

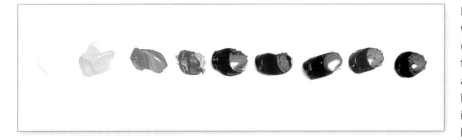

It's easier to keep your palette organized if you will lay out your beads of color from the lightest (white) at the left and ranging to the darkest at the right. You'll get in the habit of reaching for a certain color in a certain place and be less likely to pick up an incorrect color, especially if it's hard to see the difference, such as between Burnt Umber and black.

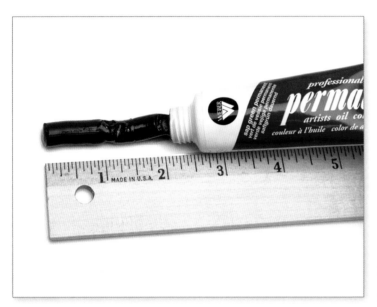

Oil colors in tubes are squeezed out on the palette in a "bead" of paint. In the instructions in the demos in this book, I will tell you how much of a bead of each color will be needed on your palette. This is a 2-inch (51mm) bead of Sap Green Permanent.

This shows the relative sizes of beads of paint: the green at top is a 2-inch (51mm) bead; the yellow is a 1-inch (25mm) bead; the orange is a ½-inch (13mm) bead; the blue is a ¼-inch (6mm) bead; and the brown is a "touch" of color. Knowing at the start how much paint will be needed prevents waste and saves you time during the color mixing and painting process.

PERMALBA PROFESSIONAL OILS

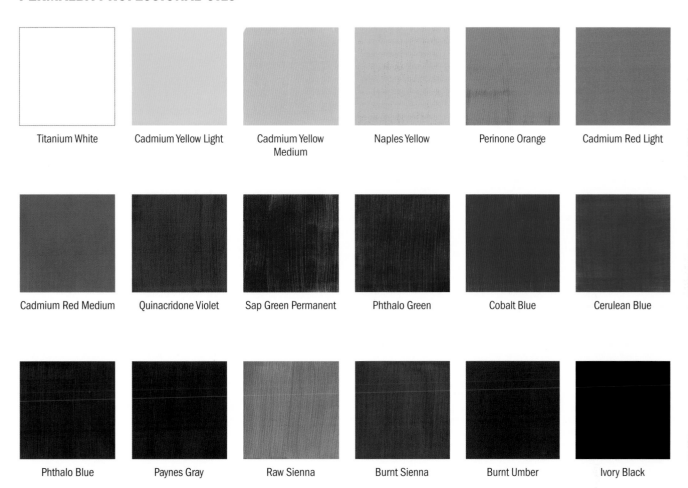

Titanium White	Cadmium Yellow Light	Cadmium Yellow Medium	Naples Yellow	Perinone Orange	Cadmium Red Light
Cadmium Red Medium	Quinacridone Violet	Sap Green Permanent	Phthalo Green	Cobalt Blue	Cerulean Blue
Phthalo Blue	Paynes Gray	Raw Sienna	Burnt Sienna	Burnt Umber	Ivory Black

For all the paintings in this book, I used Permalba Oil Paints from Martin/F. Weber. These are professional grade paints that come in tubes and are available at your local art supply store. Permalba oils are made from densely concentrated pigments, which means they have a higher ratio of color pigment to oil medium, as opposed to cheaper or student grades of oil paints which have less pigment and more medium. For painting success, always buy the best quality you can afford.

Oil Painting Tips & Techniques

LOADING A FILBERT BRUSH WITH PAINT

1. Load both sides of the filbert brush by pulling paint out of your puddle on the palette.

2. "Groom" both sides of the brush by pulling and pressing so the bristles come together.

3. A well-groomed brush has a very sharp chisel edge.

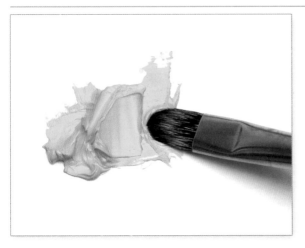

1. Gently push a clean brush forward slightly into the puddle of paint to pick up a "scoop" or bead of color along the tip of the bristles.

2. This shows how much paint is picked up in a "scoop." Note the indentation in the paint puddle where the bristles picked up the paint.

"LEAN" VERSUS "FAT" AMOUNT OF PAINT

1. When the instructions say to load your brush with a "lean" amount of paint, it means pick up a minimal amount on your brush.

2. This is a "fat" amount of paint—it is a heavier loading on the brush.

3. Compare how they look when painted on your surface. A lean amount will provide light coverage and can give a "drybrush" effect. A fat amount covers well and can provide texture.

PAINTING THE "NEUTRAL STROKE" WITH A FILBERT

2. The neutral stroke makes a small crescent-shaped mark.

1. The "neutral stroke" is used in every painting in this book to tap on foliage and clusters of foliage on evergreen and deciduous trees and bushes, and sometimes to suggest flowers in a field. To paint a neutral stroke with a filbert brush, tilt the handle slightly down and tap with the chisel edge of the brush.

3. When you tap on neutral strokes repeatedly, you begin to get clusters of leaves.

4. Repeat and fill in to get clusters of foliage.

PAINTING THE "NEUTRAL STROKE" WITH A FLAT BRUSH

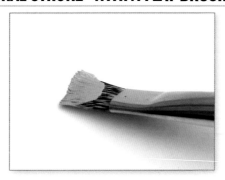

1. To paint a neutral stroke with a flat brush, hold the brush at an angle so one corner of the brush touches the surface.

2. Tap the brush's corner repeatedly to begin forming clusters of leaves.

THE WRONG WAY TO PAINT NEUTRAL STROKES

1. Don't use the flat side of your brush. You must stay on the corner.

2. Don't use the side—you'll just get straight marks.

1. When you are first blocking in color over a large area in your landscape painting, the fastest way to do it is to scrub it on with a large bristle flat. Bristle brushes are tough and are made for this kind of work.

2. When you're painting a more confined area or need a thicker application of color, blot the paint on with the side of a large filbert or flat, either a stiff bristle or a soft badger blend.

USING A FAN BRUSH

USING A MOP BRUSH

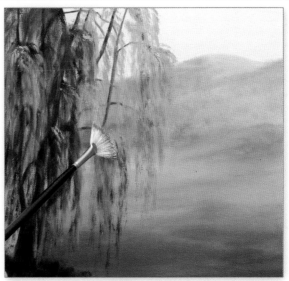

With a large, soft mop brush, you can gently stroke over the edges of puffy clouds to soften them and make them fade away into the sky. You can also blend colors seamlessly with a mop and soften the detail in a distant background.

With a fan brush and a sparse amount of paint on the tips of the bristles, you can suggest the long, skinny leaves of a willow tree or any other tree that has tiny leaves by using a very light touch and a downward, skittering, dancing motion of the brush.

APPLYING CLEAR MEDIUM TO THE CANVAS

1. Prior to painting, I often cover my entire canvas with a thin coat of clear medium, which creates a workable surface for applying and blending the oil colors. First, undercoat the canvas with an even coat of an acrylic orange paint. Let dry. Transfer the line drawing to the canvas with gray graphite paper.

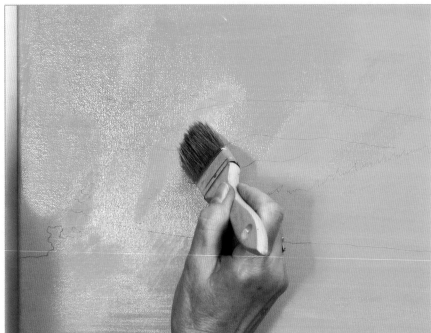

2. Apply clear medium evenly over the canvas with a large, soft, inexpensive natural bristle brush.

3. Blot excess medium from the canvas by placing a plain white paper towel over it and brushing with your large brush.

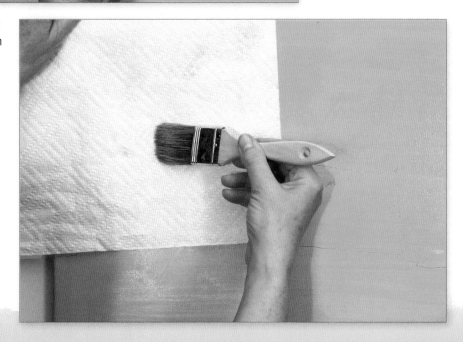

USING "LESS-THAN-IDEAL" REFERENCE PHOTOS FOR PAINTING LANDSCAPES

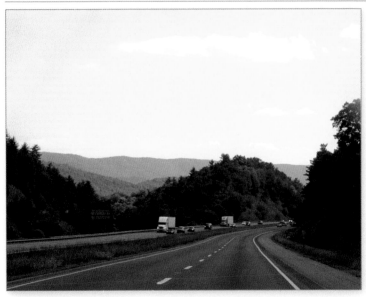

Keeping my camera handy for those sparks of inspiration from Mother Nature provides me with wonderful reference material for future paintings. Occasionally, the quick photos are less than ideal but the scene, mood, color, or point of interest has been preserved. In this photograph taken through the windshield of my vehicle, the continually rolling hills plus the variations in the colors of the trees were beautiful but the highway and the oncoming traffic were not.

In the painting below, you can see how I edited the photo to create a better composition. The highway became a peaceful sunlit valley while the distant rolling hills were preserved. I added a subtle hint of a dusty road and a rustic fence down the valley to draw the viewer in, plus a variety of tall grasses in the foreground to stop the eye from leaving the painting. Now, instead of hearing the roar of traffic, you can feel the peace and serenity of this quiet country scene.

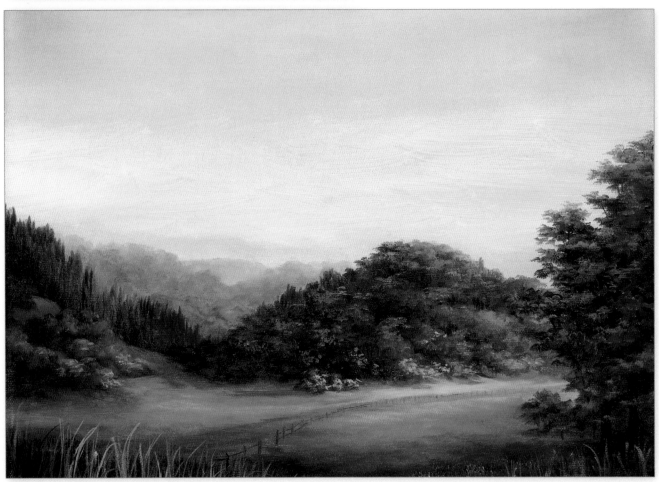

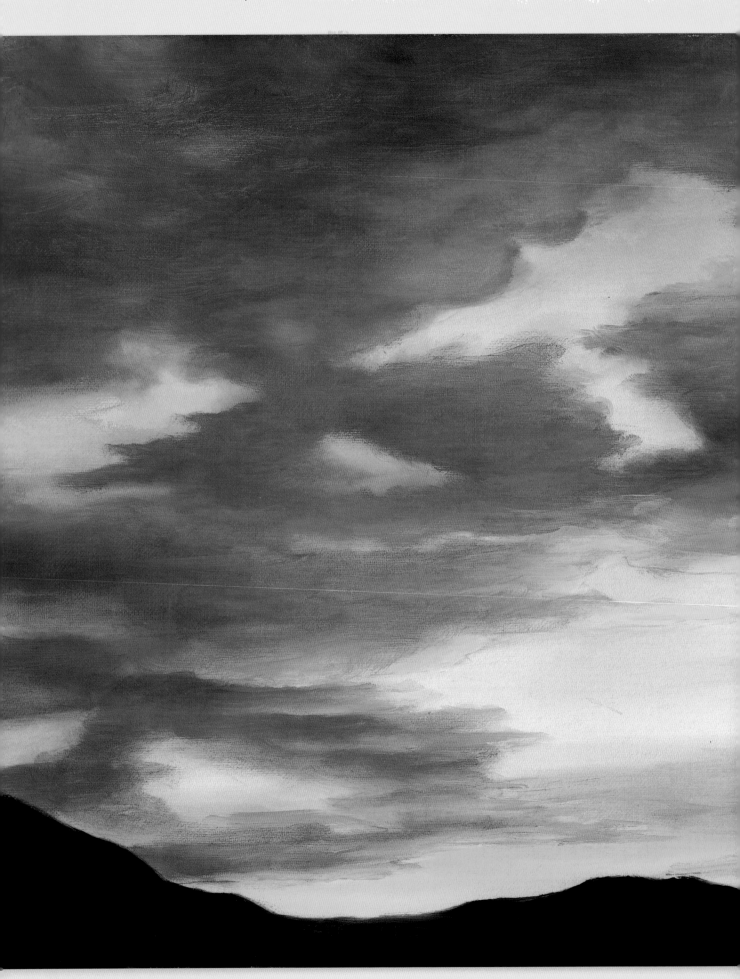

Sunset Sky

In most landscapes, the sky is the most distant element in the painting, lending almost infinite depth and distance to the scene and bringing everything else forward. In this painting, the sky is the landscape and it follows many of the same rules for achieving the illusion of depth and distance.

When painting the strong colors and values of a sunset in oils, place the most vibrant colors first. Keep these colors as clean as possible to maintain their vibrancy and build to the deeper values and shadows. Don't overwork them—once intense colors have been compromised it is very difficult to recapture their beauty.

ACRYLIC COLOR FOR UNDERCOATING

DecoArt Americana
"Orange Twist"

OIL COLOR MIXES

Sky blue mix

Shadow blue mix

Bright salmon mix

Bright yellow mix

Deep coral mix

Line Drawing

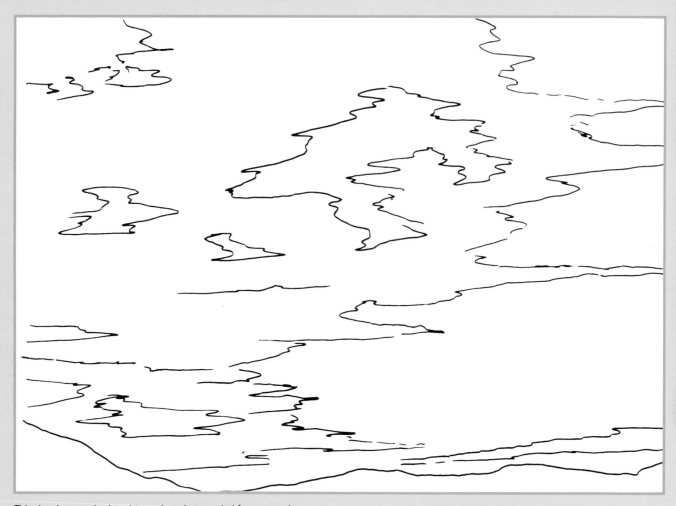

This drawing may be hand-traced or photocopied for personal use only. Enlarge at 152% to bring it up to full size.

Surface

Stretched canvas, 11 x 14 inches
(28 x 36 cm)

Acrylic paint

DecoArt Americana "Orange Twist" or other
medium orange acrylic paint

Oil paints

Permalba Professional Oil Colors.
Place the following bead-lengths on
your palette:

Titanium White: 1½ inches (38mm)

Naples Yellow: 1/8 inch (3mm)

Cadmium Yellow Light: 1/4 inch (6mm)

Perinone Orange: 3/4 inch (19mm)

Phthalo Blue: 1/3 inch (8.5mm)

Quinacridone Violet: 1/4 inch (6mm)

Paynes Gray: 1/4 inch (6mm)

Oil color mixes

Use a palette knife to mix the following colors
on your palette:

Sky blue mix: 1/2 inch (13mm) Titanium
White + touch of Phthalo Blue + smaller
touch of Quinacridone Violet

Shadow blue mix: Sky blue mix + touch of
Phthalo Blue + touch of Quinacridone Violet

Bright salmon mix: 1/4 inch (6mm) Titanium
White + touch of Cadmium Yellow Light +
touch of Perinone Orange

Bright yellow mix: 1/4 inch (6mm) Cadmium
Yellow Light + touch of bright salmon mix

Deep coral mix: 1/2 inch (13mm) Perinone
Orange + 1/8 inch (3mm) Quinacridone
Violet

Brushes

2-inch (51mm) foam, 2-inch (51mm) soft
bristle craft brush, nos. 6 and 10 stiff bristle
flats, no. 8 badger filbert, no. 24 badger flat,
1/2-inch (13mm) soft blending mop

Other materials

Clear medium mix, gray graphite paper, trac-
ing paper, paper towels, palette knife

CANVAS PREPARATION

After you have applied an orange acrylic
undercoat and transferred the drawing to the
canvas, brush a sparing amount (less than
1 tablespoon) of the clear medium mix over
the entire canvas using a 2-inch (51mm)
soft bristle brush. Work it well into the canvas.
Place a paper towel over the canvas and
brush gently over the paper towel to pick up
any excess medium. Proceed with the oil
painting.

Undercoat with Orange Acrylic and Transfer the Drawing

Cover the entire canvas
with an even undercoat of
orange acrylic paint using a
2-inch (51mm) foam brush.
Let dry completely. Trace or
photocopy the line drawing,
enlarge to the percentage
needed, and transfer to the
canvas using gray graphite
paper. Make sure the lines
show up well. Brush with
clear medium following the
instructions under "Canvas
Preparation" above.

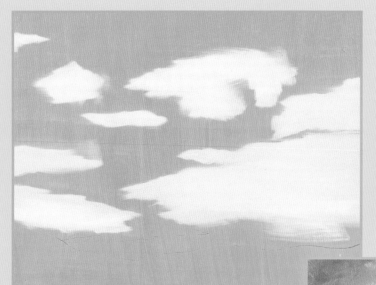

Step 1: Block In Blue Sky

Pick up sky blue mix on a no. 10 stiff bristle flat brush and loosely place this color into the mid sky area, working around the cloud patterns. Brush-mix some sky blue mix and Titanium White for a lighter value of blue and place in the lowest blue sky areas; do not take this color all the way down to the horizon line.

Step 2: Darken Upper Sky

Pick up some shadow blue mix on a no. 10 flat and block this color into the upper sky areas, allowing it to blend with the lighter sky blue where the colors meet, then progressing to the darker shadow blue in the upper and outer regions of the sky. Don't worry about the hard edges right now; we'll soften those later.

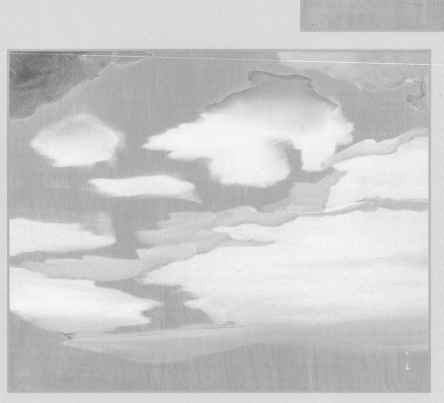

Step 3: Add Color to Clouds

With a clean no. 6 stiff bristle flat, make a brush mix of Titanium White and a touch of the bright salmon mix and place a soft pink glow in the lower sky regions just above the mountain ridges. Add a final intense value at the horizon line with a brush mix of equal parts bright salmon mix and Cadmium Yellow Light.

With the shadow blue mix on a no. 8 filbert, add very subtle distant clouds using the flat of your brush to make horizontal streaks. Using a clean filbert, highlight the undersides of the clouds where the setting sun lights them up with a brush-mix of bright yellow mix and Titanium White.

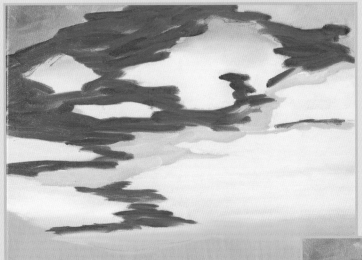

Step 4: Block in Red Clouds

Using quick, loose strokes of a small bristle flat, place sparing amounts of the deep coral mix throughout the clouds, avoiding the areas where the yellow tones have been placed. This looks very bright and intense at this point, but don't worry, these tones will be softened and blended later on. You must start with intense hues—they can't be laid in later. Once you've lost the vibrancy of these colors, you can't get them back.

Step 5: Soften and Blend Edges

Before going on, if your painting seems rather wet, let it tack up (or dry) a bit. This will make it easier to control your edges. With a no. 24 soft badger flat brush, blend the deep coral color along the edges of the clouds where they meet the sky blue color (again, stay away from the yellow tones for now). Maintain the general shape of the clouds but soften all hard edges. Wipe your brush often on a clean paper towel to remove the paint you pick up as you blend.

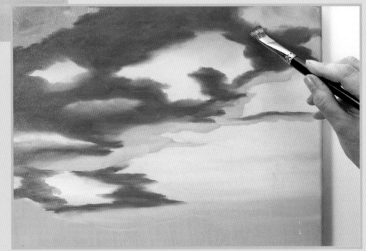

Step 6: Soften and Blend Edges

With a clean no. 24 soft badger flat, soften and blend the bright yellow edges into the deep coral clouds, but leave a lot of the bright yellow showing along the bottom edges as reflections of the brightest light from the setting sun. Again, wipe your brush on a paper towel as you blend to remove excess paint.

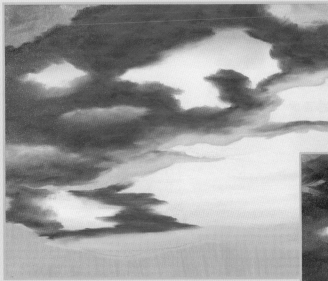

Step 7: Deepen Cloud Values

Begin adding deeper values to the clouds with a brush mix of the deep coral mix + touches of Quinacridone Violet. Lay this color in with deliberate, painterly strokes and do not overwork. Use this color sparingly, blending only slightly as they are added. The textures will be softened after all colors are in place.

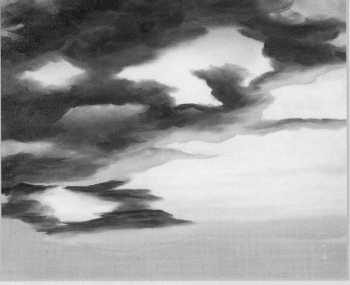

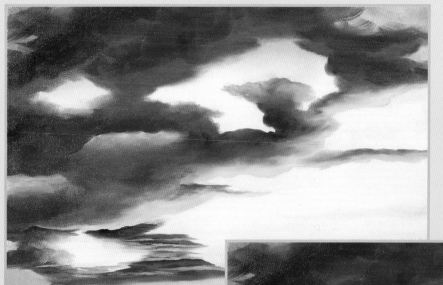

Step 8: Place Deepest Cloud Values

The deepest values in the clouds are a brush mix of trace amounts of Quinacridone Violet + Phthalo Blue. These deep values are placed on the upper left areas of the clouds, opposite from where the lightest yellow highlights are placed, since these are the most shadowed areas.

Step 9: Enrich Horizon Colors

For the lowest areas of the sky where the mountains are backlit by the setting sun, place in a brush mix of the deep coral mix plus Titanium White. The violet streak is Quinacridone Violet and white, and the pinkish tone just above it is the same mix plus a little more white.

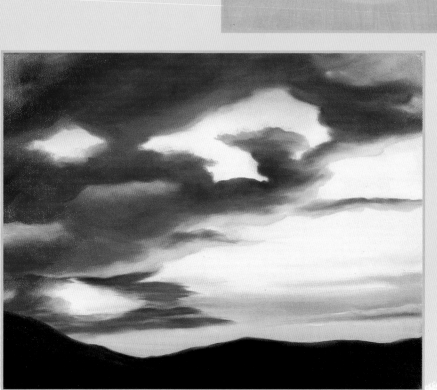

Step 10: Finish with Mountain Ridge

After all the sky colors are in place, mop gently just to soften obvious textures. Use a small ½-inch (13mm) mop and wipe it often on a paper towel. Once the vibrant colors are in place and softened, set the painting aside until the paint tacks up and will not mix with any additional layers of color added over top.

Add the dark mountain ridge with Paynes Gray and a no. 6 bristle flat. Wipe the brush and pick up some sky blue mix to add a tiny amount of glow along the top of the ridge. This softens that edge against the sky.

Landscape Lesson #1: Creating the Illusion of Distance in the Sky

Even though there are vibrant and intense colors throughout the painting, the illusion of distance is achieved by changing the size, intensity and shape of the clouds. The clouds directly overhead are visually closer to the viewer than the clouds in the distance, therefore they are larger, more intense, and have a greater billowing effect. They also contain the most intense colors, shadows and contrast with the sky itself. The clouds closer to the horizon line, above the silhouetted mountains, are more linear, less shadowed, and closer in value to the sky itself, which creates a strong sense of distance. Keeping the landform totally in shadow also helps keep the focus on the intense sunset colors of the sky.

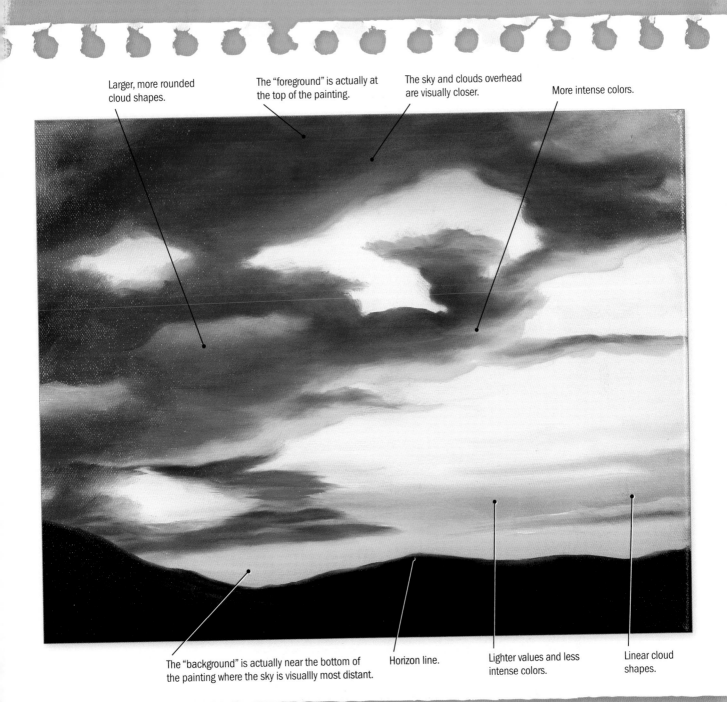

Larger, more rounded cloud shapes.

The "foreground" is actually at the top of the painting.

The sky and clouds overhead are visually closer.

More intense colors.

The "background" is actually near the bottom of the painting where the sky is visuallly most distant.

Horizon line.

Lighter values and less intense colors.

Linear cloud shapes.

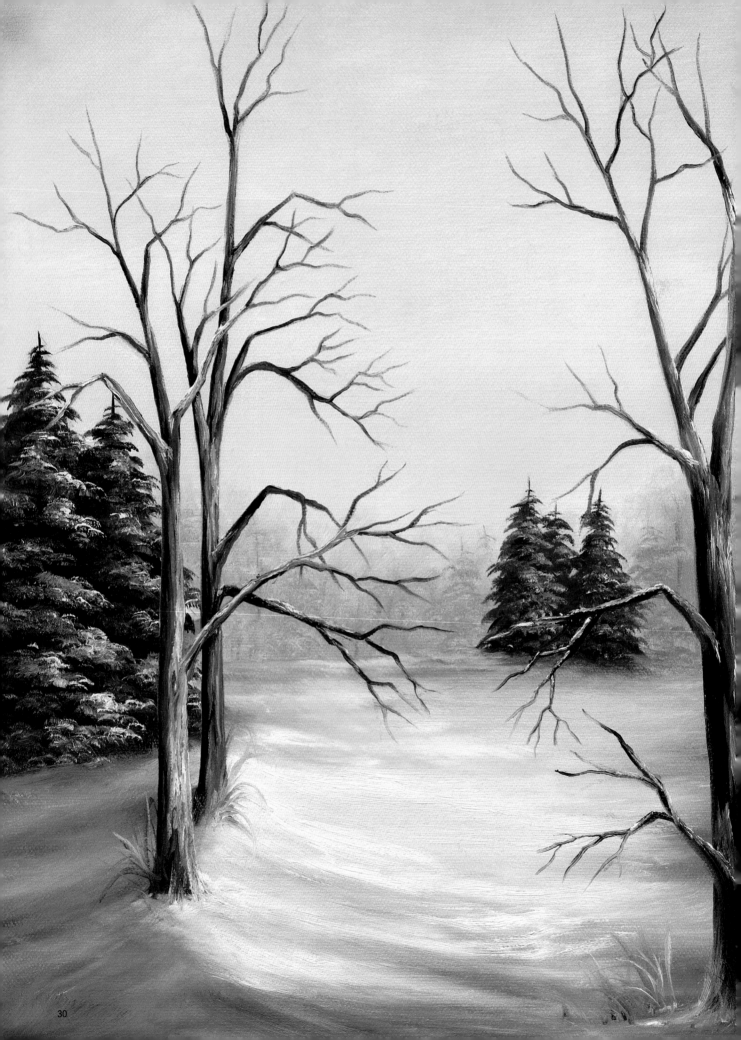

Winter's Blanket

Hazy trees in the distance, stronger evergreens in the mid-range, and detailed trees in the foreground all support the feeling of depth and distance in this painting. Since the colors of winter are naturally more muted, you can achieve depth in your painting by other means. For example, even though the trees in the far distance are similar to those in the foreground, the depth is achieved by decreasing the detail, textures, size and value of the trees as they progress into the distance. The foreground trees, grasses and bushes will be in sharper focus, have more detail included and be stronger in value than those progressing into the distance. In addition, the stronger shadows cast by the trees in the foreground contrast with the more subdued hues and values in the distance.

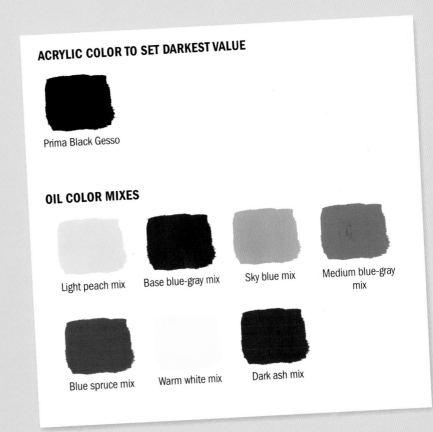

ACRYLIC COLOR TO SET DARKEST VALUE

Prima Black Gesso

OIL COLOR MIXES

Light peach mix Base blue-gray mix Sky blue mix Medium blue-gray mix

Blue spruce mix Warm white mix Dark ash mix

Line Drawing

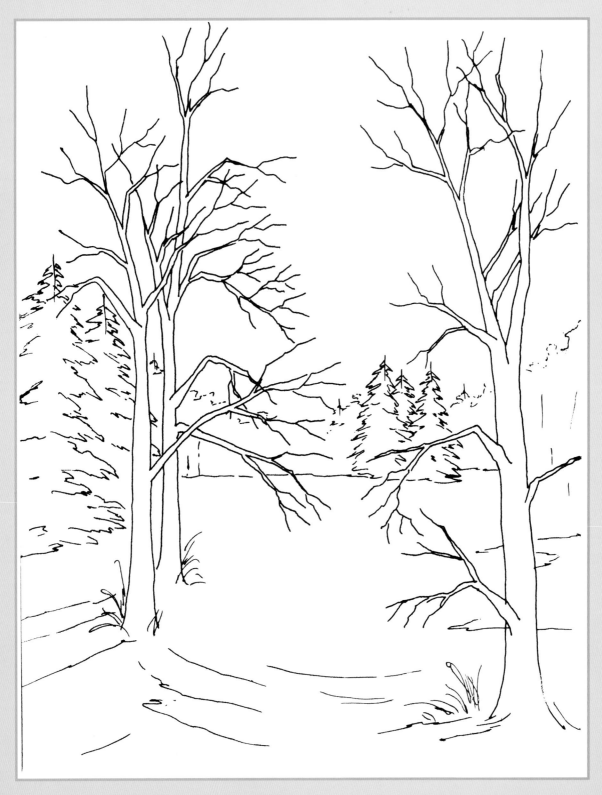

This drawing may be hand-traced or photocopied for personal use only.
Enlarge at 137% to bring it up to full size.

Surface
Stretched canvas, 16 x 12 inches
(41 x 30 cm)

Acrylic paint
Prima Black Gesso

Oil paints
Permalba Professional Oil Colors.
Place the following bead-lengths on
your palette:

Titanium White: 2 inches (51mm)

Cadmium Yellow Medium: a touch

Perinone Orange: a touch

Quinacridone Violet: 1 inch (25mm)

Phthalo Green: 1 inch (25mm)

Phthalo Blue: a touch

Burnt Umber: 1/4 inch (6mm)

Ivory Black: 1/4 inch (6mm)

Oil color mixes
Use a palette knife to mix the following colors
on your palette:

Light peach mix: 1/4 inch (6mm) Titanium
White + touch of Perinone Orange

Base blue-gray mix: 1/4 inch (6mm)
Phthalo Green + 3/4 inch (19mm) Quinac-
ridone Violet (this mix is used only as part of
the next three color mixes)

Sky blue mix: 1/3 inch (8.5mm) Titanium
White + 1/16 inch (1.6mm) each of the
base blue-gray mix and Phthalo Blue

Medium blue-gray mix: 1/2 inch (13mm)
Titanium White + 1/8 inch (3mm) base blue-
gray mix + 1/16 inch (1.6mm) Quinacridone
Violet

Blue spruce mix: 1/3 inch (8.5mm) base
blue-gray mix + scant touch of Phthalo Green

Warm white mix: 1/4 inch (6mm) Titanium
White + touch of Cadmium Yellow Medium

Dark ash mix: 1/4 inch (6mm) Burnt Umber
+ 1/4 inch (6mm) Ivory Black

Brushes
1/4 inch (6mm) synthetic bristle flat, 2-inch
(51mm) soft bristle brush, no. 10 stiff bristle
flat, no. 8 badger filbert, nos. 12 and 24 bad-
ger flats, large soft mop brush, no. 2 script
liner, no. 3 fan

Other materials
Clear medium, gray graphite paper, tracing
paper, paper towels, palette knife

Transfer the Line Drawing, Block In Dark-est Value, and Apply Clear Medium
Trace or photocopy the line drawing, enlarge
to the percentage needed, and transfer to
the canvas using gray graphite paper. Block
in the foreground tree trunks and branches
with a smooth application of black acrylic
gesso on a 1/4-inch (6mm) synthetic bristle
flat brush. Let dry completely. Brush a sparing
amount (less than 1 tablespoon) of the clear
medium mix over the entire canvas using a
2-inch (51mm) soft bristle brush. Work it well
into the canvas. Place a paper towel over the
canvas and brush gently over the paper towel
to pick up any excess medium. Proceed with
the oil painting.

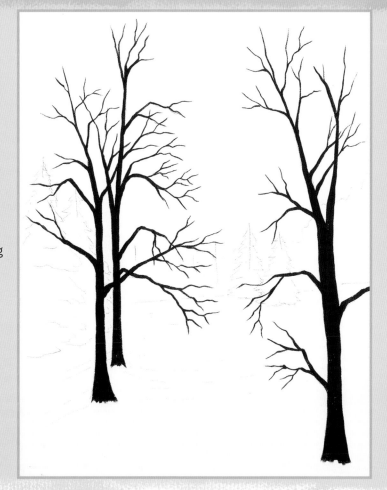

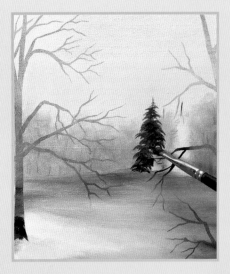

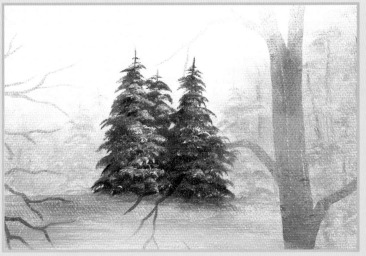

Step 7: Begin Mid-ground Evergreens

With a no. 8 badger filbert, brush-mix some blue spruce mix + Titanium White for a lighter value of blue spruce. Begin placing the mid-ground evergreens with a downward tapping "neutral stroke" (see page 18 for neutral stroke instructions).

Step 8: Highlight Foliage and Add Distant Pines

Brush-mix some sky blue mix + Titanium White for a cool white highlight. Place this sparingly on the right side and upper branches. For the pale, distant pines behind and to the right and left of these mid-range trees, tap on medium blue-gray mix with the no. 8 filbert using the neutral stroke. Pull the filbert lightly under these trees to create a shadow and to ground them.

Landscape Lesson #2: Detail Fades Away in the Distance

Hazy trees in the distance, stronger evergreens in the mid-ground, and detailed trees in the foreground all support the feeling of depth and distance. When you choose colors and values for your landscapes, always think about where things are in relation to each other. The most distant objects will be lighter in value and grayer in color.

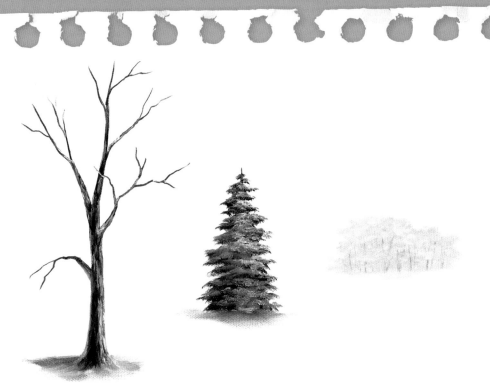

Foreground Tree
Highly detailed, sharp edges, and wider range of values

Mid-ground Tree
Less detail, edges not as sharp, values are a bit lighter

Background Trees
Almost no detail, hazy, soft edges, lighter values, grayed-down colors

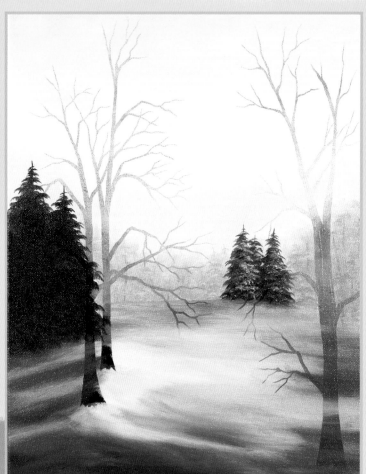

Step 9: Begin Pine Trees at Left

Place the pine trees on the left side of the painting with a lean amount of blue spruce mix on a no. 8 filbert, using slight downward taps of the brush.

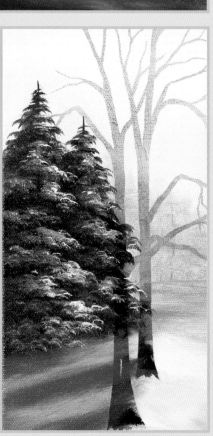

Step 10: Highlight Pine Trees

Using a no. 8 filbert, highlight the right side and upper branches with the cool white highlight mix used in Step 8.

Step 11: Add Snow to Branches

Pick up a scoop of Titanium White on the same no. 8 filbert and tap snow onto some of the branches. Do not overload with snow—be selective for the greatest impact, and maintain the deepest shadowed areas of the trees for contrast.

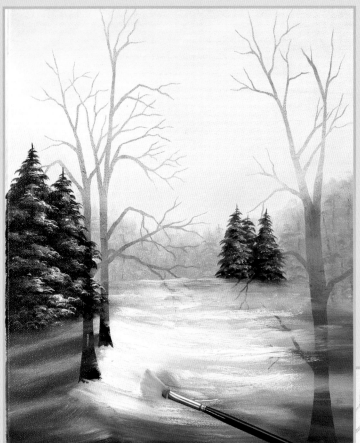

Step 12: Highlight Snow

Use a no. 12 badger flat and a cool white made from Titanium White + a touch of sky blue mix to highlight the snow in the distance where the evergreens are. Change to a no. 3 fan brush, pick up warm white mix and drag the fan loosely across the midground snow area, leaving a lot of texture at this point. Let the "snow" mound up around the tree trunks at left, then pull slightly curved strokes to the right to indicate the flatter part of the field.

Step 13: Soften Snow Textures

Soften the snow textures a bit with a large mop brush. Don't overdo—leave streaks of white and color to show high and low areas in the snow cover.

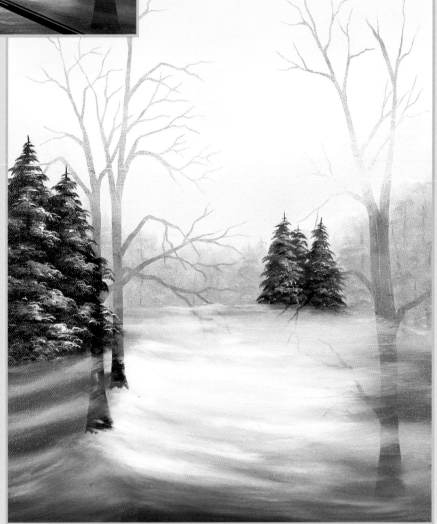

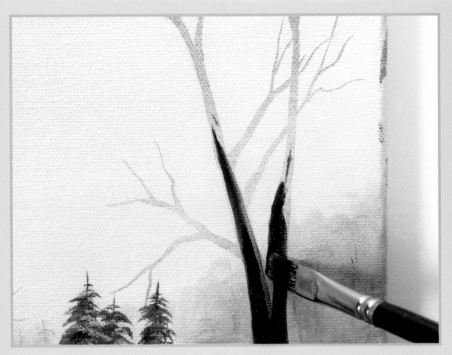

Step 14: Begin Foreground Trees

The bare trunks of the deciduous trees in the foreground are placed in with the dark ash mix. Use a no. 12 flat and stay up on the chisel edge. After loading the paint, groom the brush to get a sharp chisel edge.

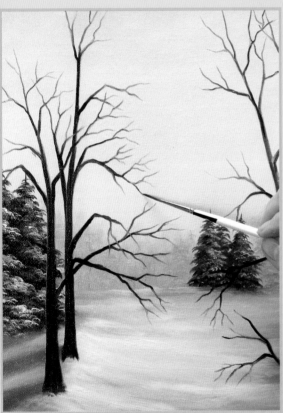

Step 15: Add Smaller Branches and Twigs

Switch to a no. 2 script liner, and thin some of the dark ash mix with a little clear medium. Paint the smaller branches and twigs. Turn the canvas and pull the lines toward you for easier painting and more control. Let the brush run out of paint as you near the ends of the smallest twigs to let them fade away for a natural look.

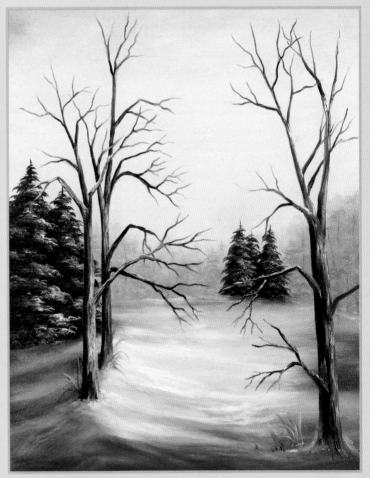

Step 16: Finish with Highlights and Grasses

Highlight the right sides of the tree trunks with light peach mix, then with a little Titanium White for snow. Add a cool highlight to the left sides with sky blue mix. Stroke in a few dried weeds and grasses around the base of the bare trees using the no. 2 script liner and the dark ash mix, highlighted with a few strokes of Titanium White.

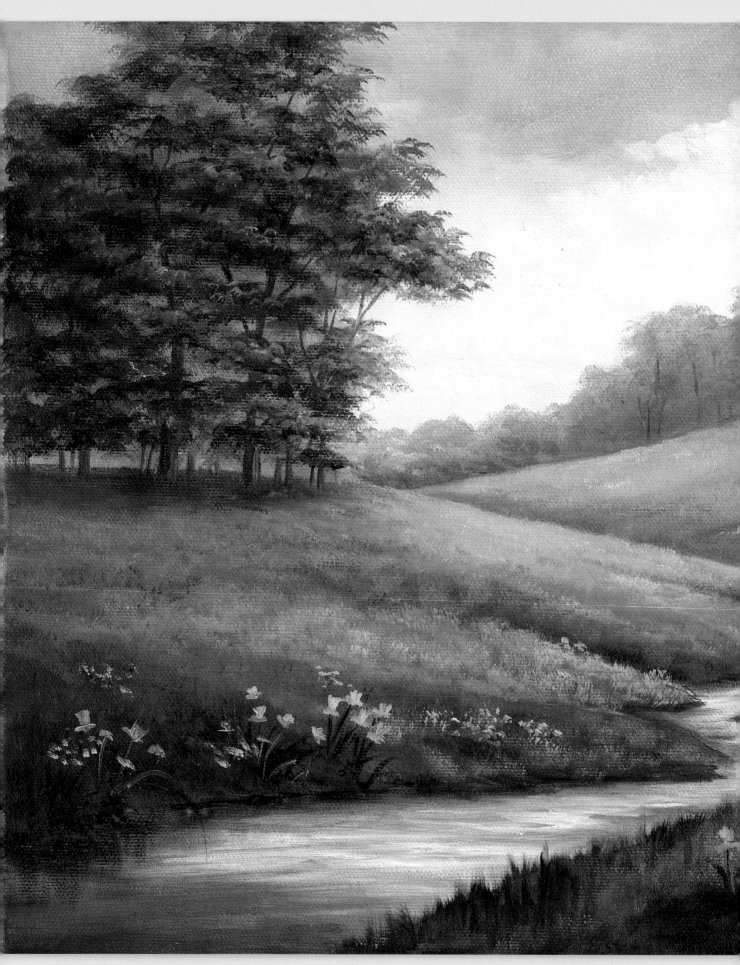

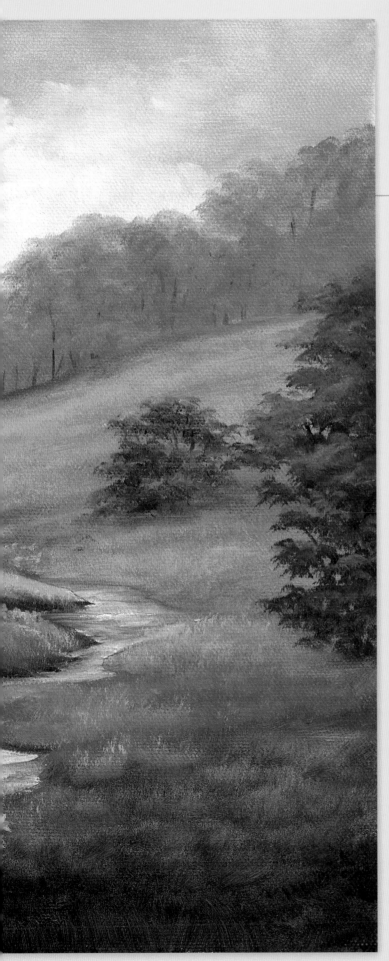

Spring Creek

In this painting of a landscape in spring, a feeling of depth is achieved even though the farthest line of trees is not too far in the distance. By subduing the colors in this line of trees and keeping detail to a minimum, they will appear to be in the background compared to the mid-range grove of trees on the left and the detailed grasses and flowers in the foreground. There is a full range of values of green in this painting, from the darkest green tones in the shaded areas of the grove, to the lightest yellow-greens in the sunlit areas of the grassy fields. The stream also leads your eye to the background, and as it disappears between the hills it implies even greater distance than what you can actually see.

OIL COLOR MIXES

Peach mix

Sky blue mix

Warm white mix

Dark green mix

Medium green mix

Dark blue-gray mix

Line Drawing

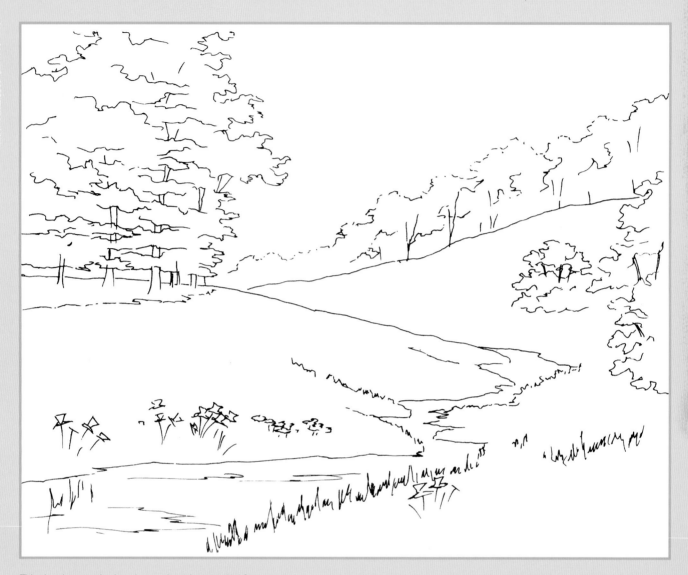

This drawing may be hand-traced or photocopied for personal use only.
Enlarge at 143% to bring it up to full size.

Surface

Stretched canvas, 11 x 14 inches (28 x 36 cm)

Oil paints

Permalba Professional Oil Colors. Place the following bead-lengths on your palette:

Titanium White: 1½ inches (38mm)

Cadmium Yellow Light: 1/8 inch (3mm)

Cadmium Yellow Medium: 1/8 inch (3mm)

Naples Yellow: 1/8 inch (3mm)

Perinone Orange: 1/8 inch (3mm)

Quinacridone Violet: 1/16 inch (1.6mm)

Cerulean Blue: 1/2 inch (13mm)

Cobalt Blue: 1/4 inch (6mm)

Sap Green: 1 inch (25mm)

Burnt Sienna: 1/8 inch (3mm)

Burnt Umber: 1/8 inch (3mm)

Ivory Black: 1/2 inch (13mm)

Oil color mixes

Use a palette knife to mix the following colors on your palette:

Peach mix: 1/4 inch (6mm) Titanium White + touch of Perinone Orange

Sky blue mix: 1/2 inch (13mm) Cerulean Blue + 1/16 inch (1.6mm) Titanium White + touch of Quinacridone Violet

Warm white mix: 1/4 inch (6mm) Titanium White + scant touch of Cadmium Yellow Medium

Dark green mix: 1 inch (25mm) Sap Green + 1/3 inch (8.5mm) Ivory Black + 1/8 inch (3mm) Cerulean Blue

Medium green mix: 1/3 inch (8.5mm) Titanium White + 1/4 inch (6mm) dark green mix

Dark blue-gray mix: Sky blue mix + touch of Cobalt Blue + touch of Ivory Black

Brushes

no. 10 stiff bristle flat, nos. 6 and 10 badger filberts, no. 12 badger flat, large soft mop brush, nos. 1 and 2 script liners

Other materials

Liquiglaze medium for brush-mixing into your colors to control the drying time, gray graphite paper, tracing paper, paper towels, palette knife

Transfer the Line Drawing

Trace or photocopy the line drawing, enlarge to the percentage needed, and transfer to the canvas using gray graphite paper. Make sure the lines show up well. Proceed with the oil painting.

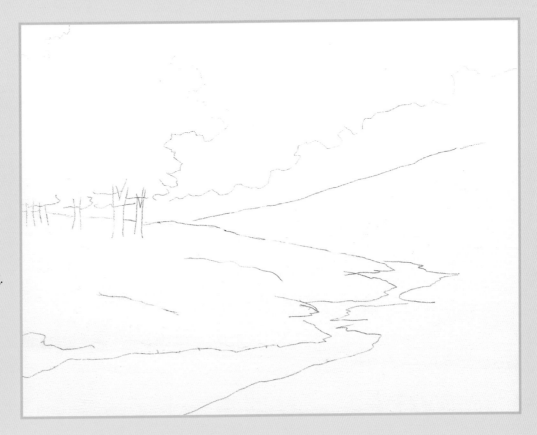

Landscape Lesson #3: The Importance of Values in Creating Distance

The study below is a simplified version of "Spring Creek" that clearly shows the different values of green used to create the illusion of distance. There is a full range of values in this painting, from the darkest green tones in the shaded areas of the grove of trees at the left, to the lightest yellow-greens in the sunlit areas of the grassy fields. The tree lines in the distance are close in value to each other, which implies that the trees themselves are adjacent. The color of the water in the creek ranges from darkest blue in the foreground to palest blue in the distance. This, combined with the narrowing of the creek bed, creates the feeling that the creek meanders off into the distance and continues on between the hillsides.

The wide range of values in the tree foliage shows that this tree is in the mid-ground.

This tree line is painted with a light value gray-green, which shows that it is the further in the distance than any other.

Your eye is led into the distance by the lessening of detail, lighter values in the tree foliage and the softening of shadow values under the trees.

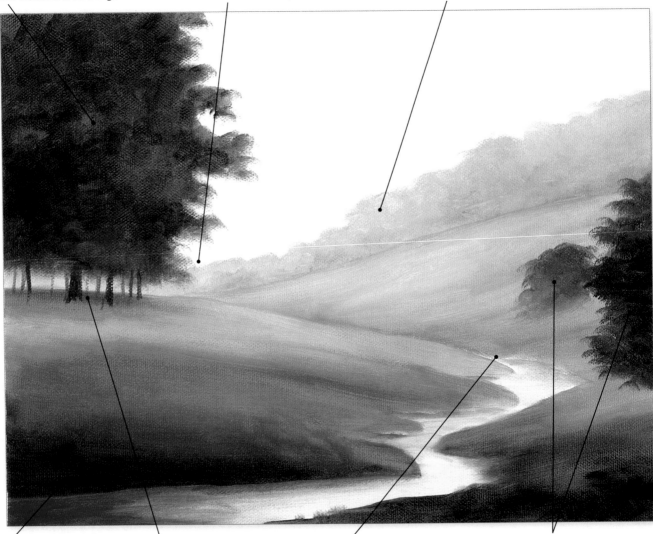

The darkest values of green and blue are here, which tells your eye that these areas are closest to you.

The multiple tree trunks seen through and under this foliage imply that there are many trees within the grove, giving a feeling of depth beyond what is actually visible.

The creek leads the eye from the foreground, with its deep shadows, into the distance with lighter colors and values while it becomes narrower and disappears around a bend in the embankment.

Compare the values of the larger and smaller trees. The lighter value of the smaller tree helps push it into the distance.

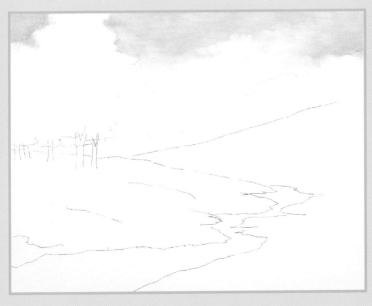

Step 1: Base In Sky and Clouds

With the peach mix and a no. 10 stiff bristle flat, loosely base in the lower part of the sky area. With the sky blue mix, block in the blue sky area from the top of the canvas downward, blending with the peach where the two colors meet. Soften and blend with a large mop brush. Place soft clouds in the lower sky area with warm white mix. Brighten some of the cloud tops with thicker white paint, then gently mop to soften the edges.

Step 2: Block in Distant Tree Line

With a no. 12 badger flat, brush-mix a cool gray-green using the medium green mix, peach and a speck of Cobalt Blue. Block in the most distant trees, using a very lean amount of paint and keeping texture to a minimum. Switch to a no. 6 badger filbert and detail the tops of trees where they are silhouetted against the sky and clouds. Let the detail and the color fade out a bit as the tree line goes to the left. Highlight the trees with taps of peach mix where the sky above is peach colored. Add texture and color variations to the trees up on the right side using a light green brush mix of Titanium White + a little touch of Sap Green. Indicate tree trunks using a brush-mix of the dark green mix and the cool gray-green on a no. 1 script liner.

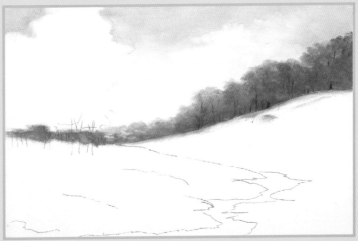

Step 3: Place Distant Hillside

With a bristle brush and the cool gray-green mix plus peach, work in the distant hillside that slopes gently downward to the valley and curves around the stream. The values should become a little darker as you work forward. Some streaking at this stage will begin the illusion of lights and shadows in the high and low places. Tap the chisel edge of your bristle brush over this hillside to suggest some grasses.

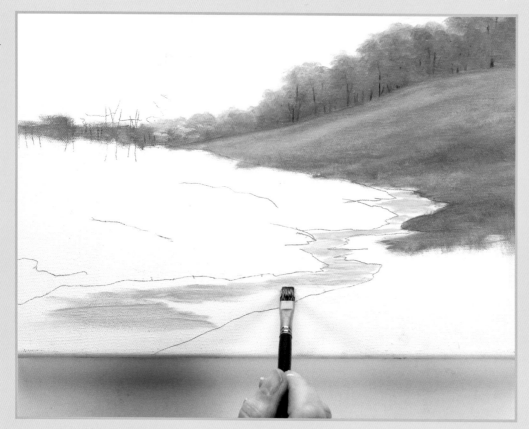

Step 4: Base In Creek Water

Base in the central area of the creek with sky blue mix on the chisel edge of a no. 12 badger flat. Use only horizontal motions to suggest rippling water.

Step 5: Deepen Water Values

Make a dark blue-gray mix using the sky blue mix plus a touch of Cobalt Blue and a touch of Ivory Black. Darken the water where it meets the edges of the embankments. Blend this color outward somewhat into the lighter blue center of the stream, and bring it all the way across in the near foreground. Darken and shade the darkest areas of the water with a brush-mix of Quinacridone Violet and Cobalt Blue.

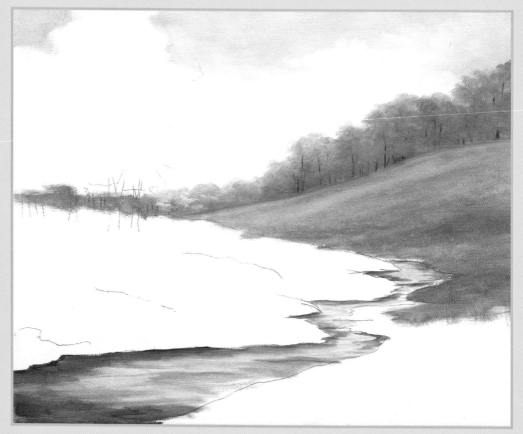

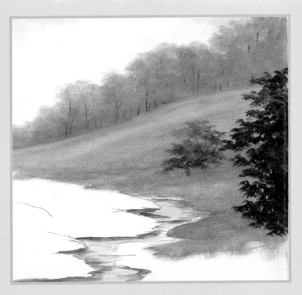

Step 6: Place Mid-ground Trees

With dark green mix on a no. 6 badger filbert, tap in the shapes of the foliage on the tree on the far right. The little tree to its left is tapped on with medium green mix. The change in value, color and size all help to push the little tree further into the distance compared to the bigger, darker tree.

Step 7: Add Stream Banks

With earthy colors of Burnt Sienna and dark green mix, place in the muddy stream banks, varying the colors on your brush and pulling them upward and to the left from the water. Bring the medium green of the grassy hillside down to meet the muddy stream banks and blend the colors slightly to show that the hillside drops off, creating the valley of the stream bed.

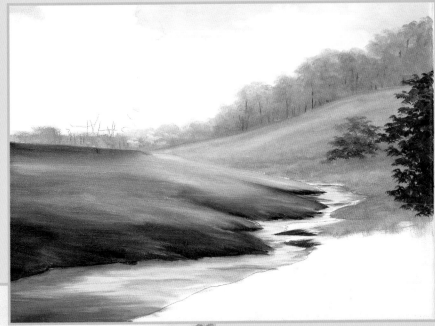

Step 8: Tap In Lighter Green Values

Where the sunlight is strongest on the distant hillside, tap in highlights of a Cadmium Yellow Light + Titanium White brush-mix. Add a light spring green highlight to other areas of the grassy hillsides on both sides of the stream with a brush-mix of Titanium White + a touch of Sap Green. Use this same light spring green to highlight the two trees on the right.

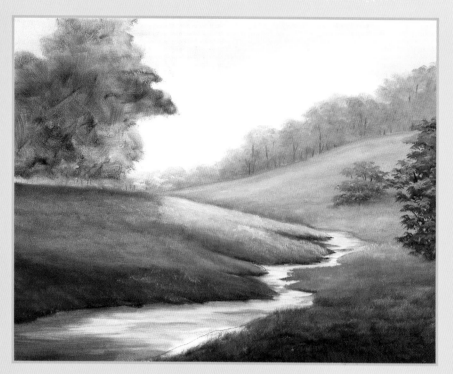

Step 9: Place Grove of Trees and Grass

The large grove of trees on the top of the hill on the left is based in with dark green mix thinned with Liquiglaze for a transparent green. This same thinned green is used to base in the grassy foreground on the right. Use a large stiff bristle brush to base in both these areas to get good textures.

Step 10: Finish Grove of Trees

Switch to a no. 10 filbert, pick up varying amounts of the dark green mix and tap on darker foliage in the large trees, allowing large areas of the original transparent green from step 9 to show through. With a brush-mix of medium green and dark green, tap on the outer silhouette of the tree foliage against the sky using the neutral stroke. Line in the trunks and branches with Burnt Umber and dark green. Shade the grassy areas under the trees with taps of dark green mix.

Step 11: Add Ripples to Water

Finish the stream with little ripples and shimmers of reflected light using Titanium White on the chisel edge of a flat brush. These are simply horizontal lines and wavy lines placed in the lighter blue of the stream's center. Pull grasses up in front of the stream with dark green on the chisel edge of a flat brush. Vary the height of the grasses.

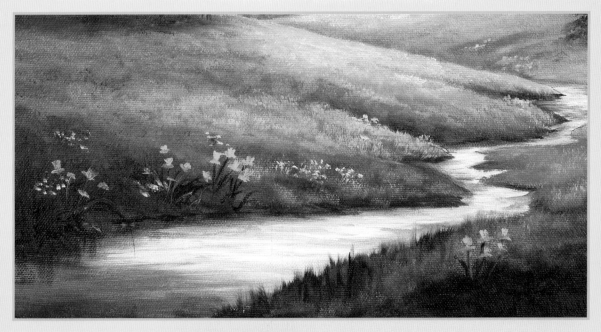

Step 12: Paint Spring Flowers along Embankment

Use a no. 1 liner and dark green mix to pull leaves and stems that grow up and curve over the shaded area of the stream at bottom left. With a clean liner, pick up Cadmium Yellow Light and stroke in shapes that suggest bright yellow daffodils. Some of the petals can be a slightly darker Cadmium Yellow Medium. To suggest small pink flowers, just touch the tips of the bristles to the canvas using a brush-mix of Quinacridone Violet and Titanium White. As the stream moves into the distance, the flower values should lighten and the flowers themselves should become less distinct.

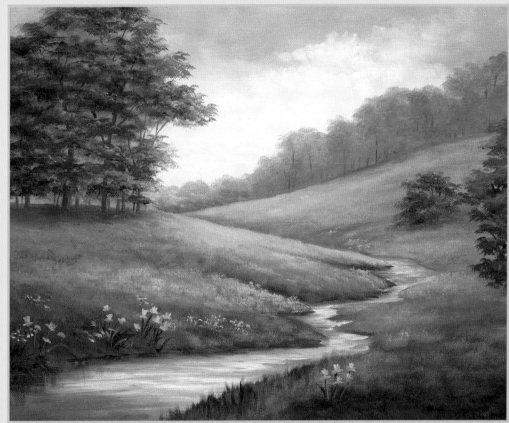

Step 13: Check Colors and Values

Take a final look at your entire painting to see that your colors and values are correct. Compare your painting to the value schematic on page 44 to help you see where the lightest lights and darkest darks should be, and that all other values are correct relative to where they are in the painting. In a painting such as this where green is the dominant color, it's more important than ever to make sure you have a full range of values.

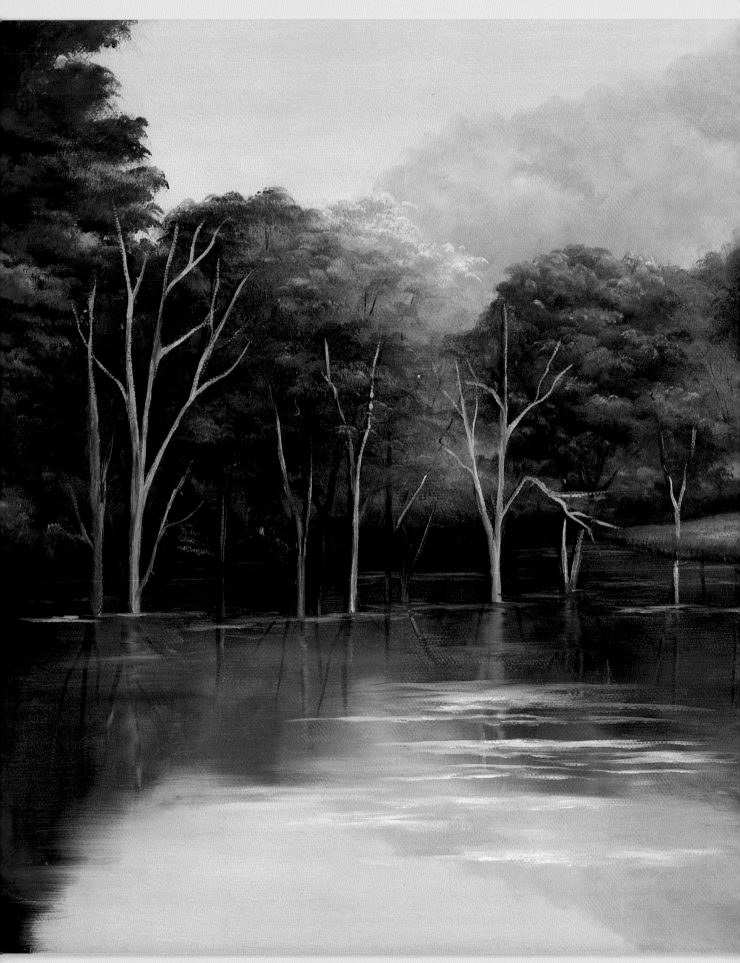

Water Colors

Controlling the temperature and vibrancy of autumn colors while distributing them throughout the scene is the challenge of this painting. The colors will be stronger in the foreground, toning down into the mid range and becoming very muted and subtle as they recede into the distance. The variations in size and detail of the trees support the feeling of depth as well. The reflected autumn colors in the water are not as strong in value or detail but add definite drama to the painting's foreground. The contrast between the details of the foreground water shimmers and the hazy trees on the most distant hillside also adds to the illusion of depth.

ACRYLIC COLORS

DecoArt Americana "Orange Twist"

Prima Black Gesso

OIL COLOR MIXES

Sky blue mix

Peach mix

Autumn green mix

Olive green mix

Light green mix

Golden yellow mix

Line Drawing

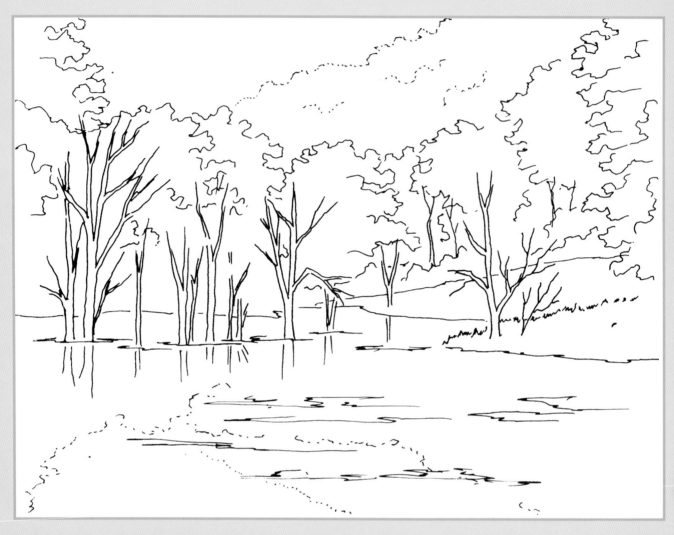

This drawing may be hand-traced or photocopied for personal use only.
Enlarge at 141% to bring it up to full size.

Surface

Stretched canvas, 12 x 16 inches
(30 x 41 cm)

Acrylic paints

DecoArt Americana "Orange Twist" or other medium orange acrylic paint. Prima Black Gesso to base in darkest values.

Oil paints

Permalba Professional Oil Colors.
Place the following bead-lengths on your palette:

Titanium White: 1½ inches (38mm)

Cadmium Yellow Medium: 1/8 inch (3mm)

Naples Yellow: 1/8 inch (3mm)

Perinone Orange: 1/8 inch (3mm)

Cadmium Red Light: 1/16 inch (1.6mm)

Sap Green: 1/2 inch (13mm)

Quinacridone Violet: 1/8 inch (3mm)

Phthalo Blue: 1/4 inch (6mm)

Raw Sienna: 1/8 inch (3mm)

Burnt Sienna: 3/8 inch (10mm)

Ivory Black: 1/3 inch (8.5mm)

Oil color mixes

Use a palette knife to mix the following colors on your palette:

Peach mix: 1/4 inch (6mm) Titanium White + touch of Perinone Orange

Sky blue mix: 1/2 inch (13mm) Titanium White + touch of Phthalo Blue + touch of Quinacridone Violet

Olive green mix: 3/8 inch (10mm) Sap Green + 1/8 inch (3mm) Ivory Black

Autumn green mix: 3/8 inch (10mm) Burnt Sienna + 1/8 inch (3mm) Phthalo Blue

Light green mix: 1/4 inch (6mm) Titanium White + touch of olive green mix + scant touch of Ivory Black

Golden yellow mix: Equal parts Cadmium Yellow Medium + Naples Yellow

Brushes

2-inch (51mm) foam, 2-inch (51mm) soft bristle craft brush, 1/4 inch (6mm) synthetic bristle flat, nos. 6, 8 and 10 stiff bristle flats, nos. 6 and 8 badger filberts, no. 2 script liner, nos. 12 and 24 badger flats, large soft mop brush

Other materials

Clear medium mix, gray graphite paper, tracing paper, paper towels, palette knife

CANVAS PREPARATION

After you have applied an orange acrylic undercoat, transferred the drawing to the canvas, and based in the tree trunks with black gesso as described below, brush a sparing amount (less than 1 tablespoon) of the clear medium mix over the entire canvas using a 2-inch (51mm) soft bristle brush. Work it well into the canvas. Place a paper towel over the canvas and brush gently over the paper towel to pick up any excess medium. Proceed with the oil painting.

Undercoat with Orange Acrylic, Transfer the Drawing and Base In the Tree Trunks

Cover the entire canvas with an even undercoat of orange acrylic paint using a 2-inch (51mm) foam brush. Let dry completely. Trace or photocopy the line drawing, enlarge to the percentage needed, and transfer to the canvas using gray graphite paper. Make sure the lines show up well. Using black acrylic gesso and a 1/4 inch (6mm) synthetic bristle flat, base in the tree trunks and their reflections, and let dry completely. Brush with clear medium following the instructions under "Canvas Preparation" above.

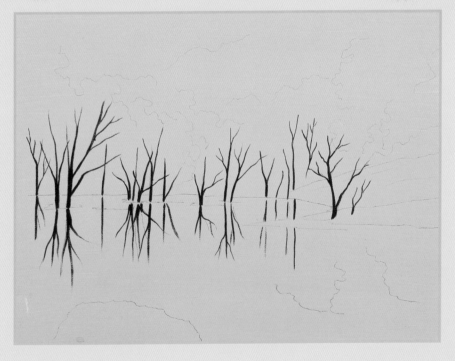

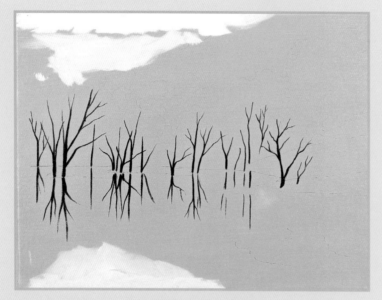

Step 1: Place Sky and Reflection Colors

With a no. 10 stiff bristle flat, pick up the peach mix and work this color into the lower sky area and into its reflection in the water. Wipe out the brush with a paper towel and pick up the sky blue mix. Place this blue in the upper sky area and work down. Also place this blue into its reflection in the water. Note that the sky and its reflection are directly opposite each other on the canvas.

Step 2: Tap On Distant Trees

Blend these two colors where they meet, both in the sky and in the reflections, with the no. 10 bristle flat. Using a no. 8 badger filbert, brush-mix a muted light green for the distant tree-covered hill with Titanium White, the olive green mix, and a touch of Ivory Black. Tap this color on using the neutral stroke and varying the greens by heavier or lighter applications of color. Use a light application of this color for the reflection in the water. Mop gently with a large soft mop brush to soften the textures.

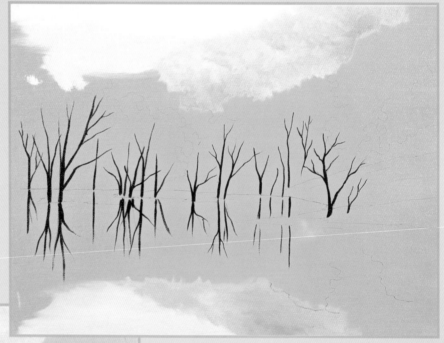

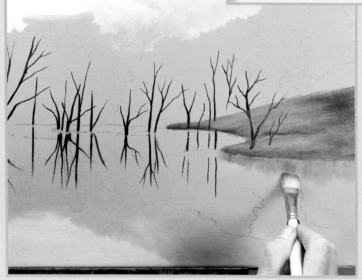

Step 3: Base In Land Area

Base in the land area to the right with slanting strokes of Raw Sienna on a no. 8 bristle flat. Darken the far right of the banks with Burnt Umber. Add Burnt Umber along the water's edge and stroke this color upward into the banks. Using the chisel edge of the flat, pull this color straight downward to create reflections in the water.

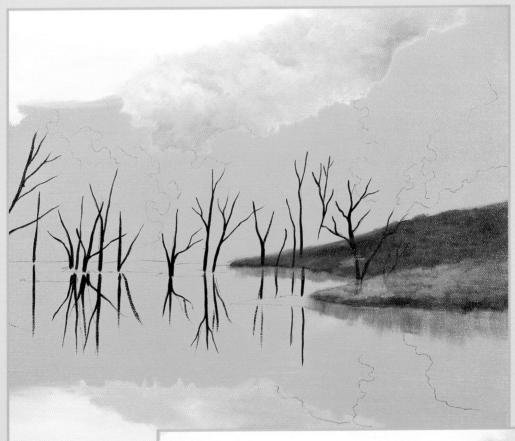

Step 4: Add Grasses to Land Area

Add grass textures with a stiff bristle flat brush and the autumn green mix. Lighten the foreground grassy area with a golden yellow brush-mix of equal parts Naples Yellow and Cadmium Yellow Medium. Paint right over the bare tree trunks—these will be re-established later on.

Step 5: Begin Placing in Mid-ground Trees

Working with the olive green mix on a no. 10 bristle flat, base in the entire background area of trees along the far shore of the lake and up the right bank. Allow this green value to vary and remain rather transparent in many areas.

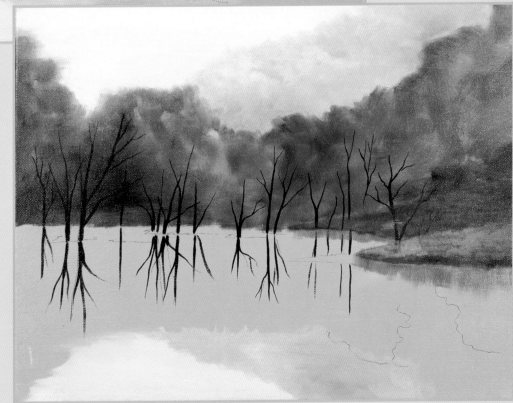

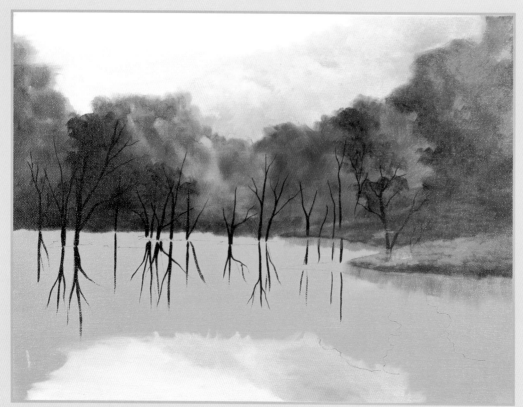

Step 6: Dark Green Trees
With a no. 8 badger filbert, pick up olive green mix and establish the dark green tree shapes along the far shore. Use the neutral stroke to tap on this color.

Step 7: Begin Adding Fall Colors
For the first highlight color for the orange and yellow trees, start with Naples Yellow and use the no. 8 badger filbert and the neutral stroke to tap on the color.

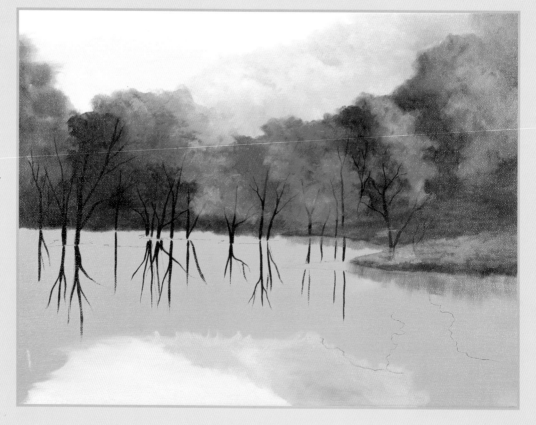

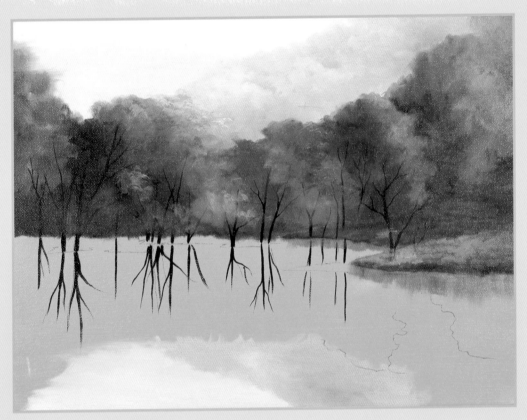

Step 8: Final Highlights

The final highlight for the yellow trees is a brush-mix of Cadmium Yellow Medium + Titanium White, tapped on with the no. 8 filbert. The final highlight for the orange trees is a brush-mix of Cadmium Yellow Medium + Perinone Orange. The leaves at the tops of the trees that are catching the most light are the brightest yellow or brightest orange; the colors should dull down as you get further down the tree into the shaded areas. Lighten the greens of the underbrush along the far shoreline with Naples Yellow.

Step 9: Large Green Trees

Paint the first layer of foliage on the two large green trees at the left and right sides with the autumn green mix and the no. 8 filbert. Where this green overlaps the pink glow in the sky on the left side, you will get a very light green—this is good. It shows that the tree is rounded or that there is another tree behind it in the distance. The large green tree in the center is started with a brush-mix of the olive green and the autumn green.

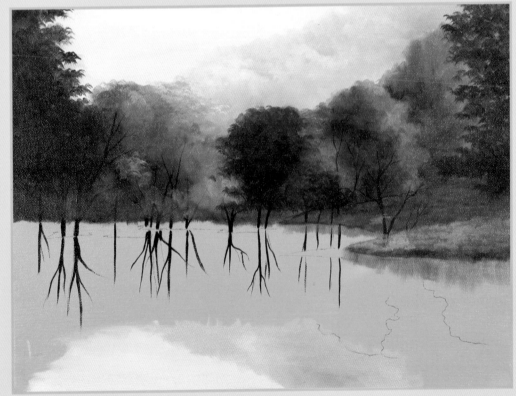

Step 10: Highlight Center Green Tree

Highlight the center green tree with Cadmium Yellow Light on a no. 6 badger filbert, tapping it in well so it picks up the green paint underneath and tones down a bit. Add a few tiny touches of pure Cadmium Yellow Light for sparks of yellow leaves on this tree.

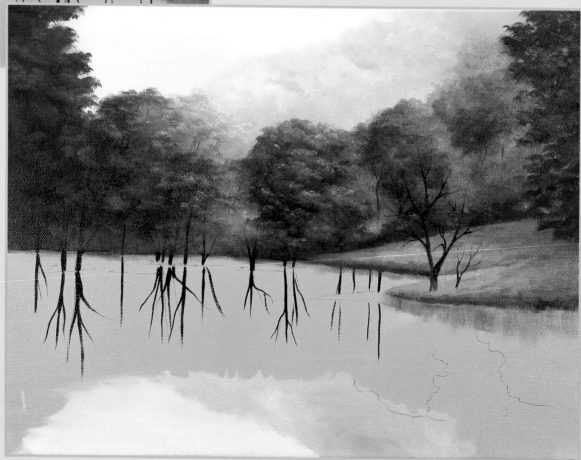

Step 11: Detail the Trees

The light green tree to the right of the center green tree is tapped on with a brush-mix of Sap Green and Titanium White. The large tree at the far right is highlighted with Naples Yellow.

A few touches of Cadmium Red Light are added to the darker foliage at the left, and some grass textures are tapped into the banks at right with Naples Yellow and highlighted with Cadmium Yellow Light. With a no. 2 script liner and thinned autumn green mix, line in some trunks and branches among the foliage along the far lakeshore. Base in the bare trees on the right banks with the same brush and color. The highlighting on all the tree trunks will be done later.

Landscape Lesson #4: Defining Background, Mid-ground and Foreground

When you look at the flat plane of a landscape painting on canvas, sometimes it is unclear which elements of the landscape are in the background, which are in the middle ground, and which are in the near foreground, closest to the viewer. There are no sharp dividing lines in most pictures; rather it is a gradual continuum. In this lesson, I have drawn a simple diagram over the painting to indicate which parts of the painting are where in that continuum. Use exercises like this to train your eye to see relative distance in any painting you look at. This will help you decide where to place your landscape elements, and what colors, values and sizes those elements should be.

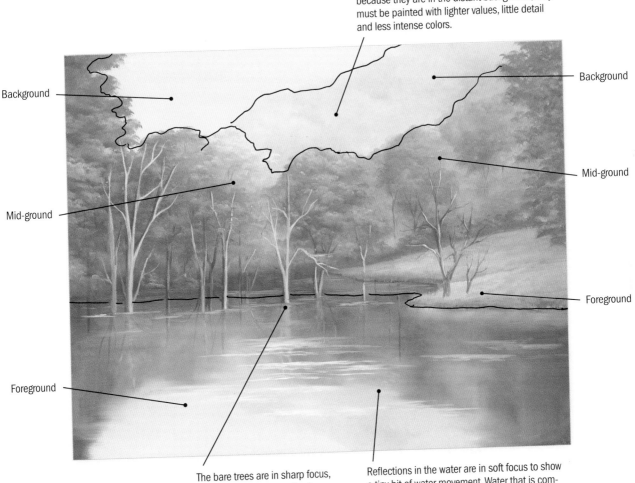

There are autumn colors in these trees too, but because they are in the distant background, they must be painted with lighter values, little detail and less intense colors.

Background

Background

Mid-ground

Mid-ground

Foreground

Foreground

The bare trees are in sharp focus, bringing them closer to the foreground than the colorful trees along the shoreline.

Reflections in the water are in soft focus to show a tiny bit of water movement. Water that is completely still would provide a mirror image.

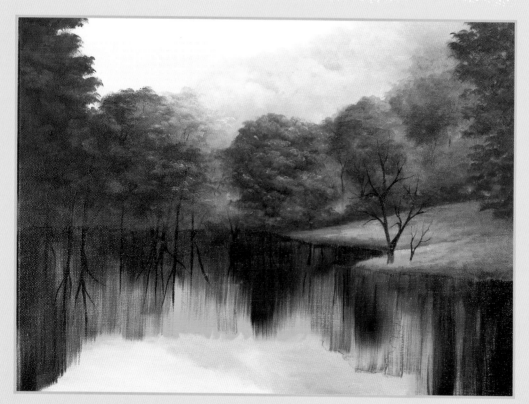

Step 12: Lake Water

Begin blocking in the lake water along the center shoreline with olive green mix grayed down with a little Ivory Black, and autumn green mix along the left and right sides. Use only vertical strokes with the no. 24 badger flat. The colors are darkest along the shoreline and fade out as they come forward to the center of the lake. Avoid painting over the sky reflections and distant hill reflections in the water.

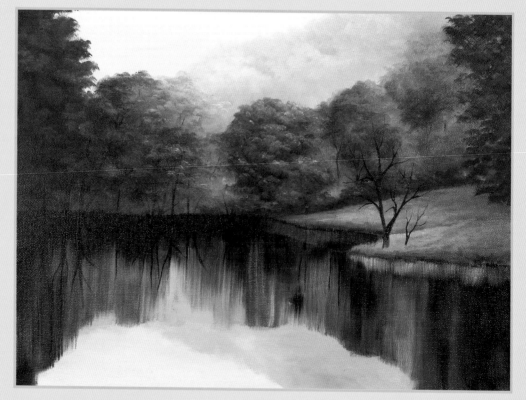

Step 13: Place Reflected Colors in Water

Place the orange, red, yellow, and light green reflection colors in the water directly underneath the trees of those colors. Use the same colors you used to paint the foliage and keep your strokes vertical. Again, avoid painting over the pink and blue sky reflections in the near fore-ground of the water. Along the shoreline of the banks at right, use Naples Yellow for the reflections of the grass colors in the water.

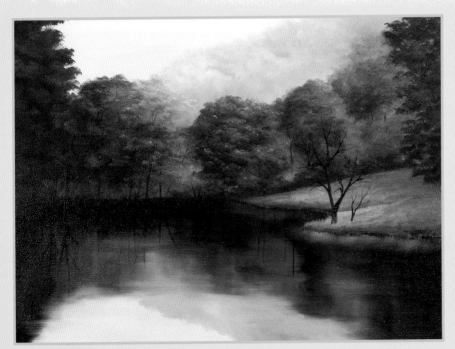

Step 14: Blend Reflections

To begin blending the reflected colors in the lake water, use the flat side of a clean no. 24 badger flat and only horizontal motions with very light pressure. Blend outward from the lightest colors into the darker colors, wiping your brush on a paper towel after every stroke to keep the colors clean. Using a clean, dry (no moisture in the brush at all) badger flat, turn the brush to the chisel edge and indicate some horizontal lines of water movement and fine ripples that reflect the orange foliage. You are actually removing paint so the orange undercoat shows through; you are not applying more orange paint.

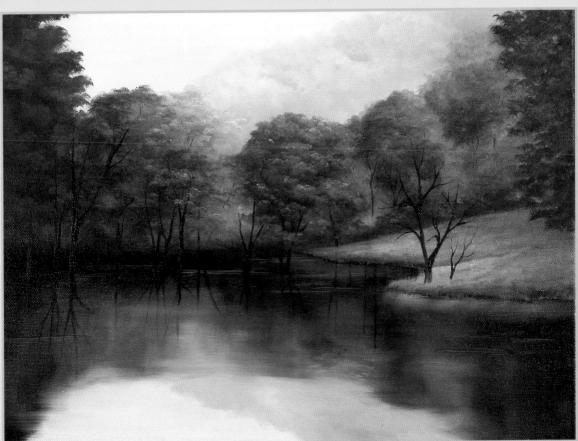

Step 15: Begin Bare Trees

The bare, white-barked trees emerging up from the water are lined in with autumn green mix on a no. 2 script liner. The reflections of these bare trees were already placed in with black gesso (refer back to page 53) so these do not need to be repainted.

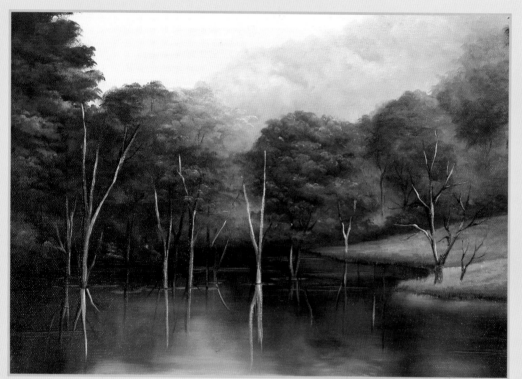

Step 16: Lighten Tree Bark

On your palette, thin a puddle of the peach mix and the Titanium White with clear medium. These colors need to be very soft. Use a no. 2 script liner and lighten the bark on all the trees with peach, including the reflections in the water directly beneath. As you paint over the colors underneath, the peach will darken in places and stay lighter in others. Pull one continuous line for each tree; we will come back in the next step and indicate the separation of the actual tree from its reflection in the water.

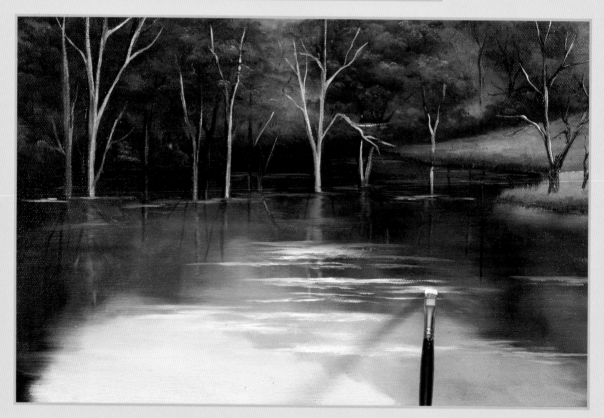

Step 17: Add Waves and Ripples in the Water

Diffuse the tree reflections in the water by dragging a clean no. 12 badger flat gently across the water area. To suggest water movement around the trees emerging from the water, and to separate the actual trunks from their reflections, pick up sky blue mix on the chisel edge of a no. 6 bristle flat and use light horizontal strokes to add little ripples and shimmers. Where the light is stronger in the center of the lake and the ripples are more active, use the same brush but pick up Titanium White. Touch on the white, then pull out lines to the left and right.

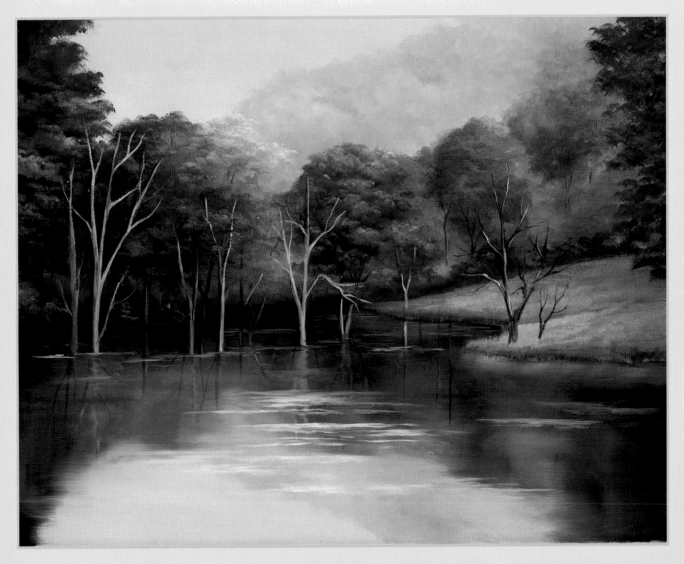

Step 18: Final Details

Deepen and enrich the blue and peach areas of the sky and its reflection in the foreground water. Add some subtle reflected tree colors along the far shoreline among the deep shade of the overhanging trees. Soften the reflections of the landmass at right. Detail and shade the rough bark of the bare trees here and there with autumn green mix to set them back just a little—you don't want them to compete with the beautiful fall colors and the reflections in the water.

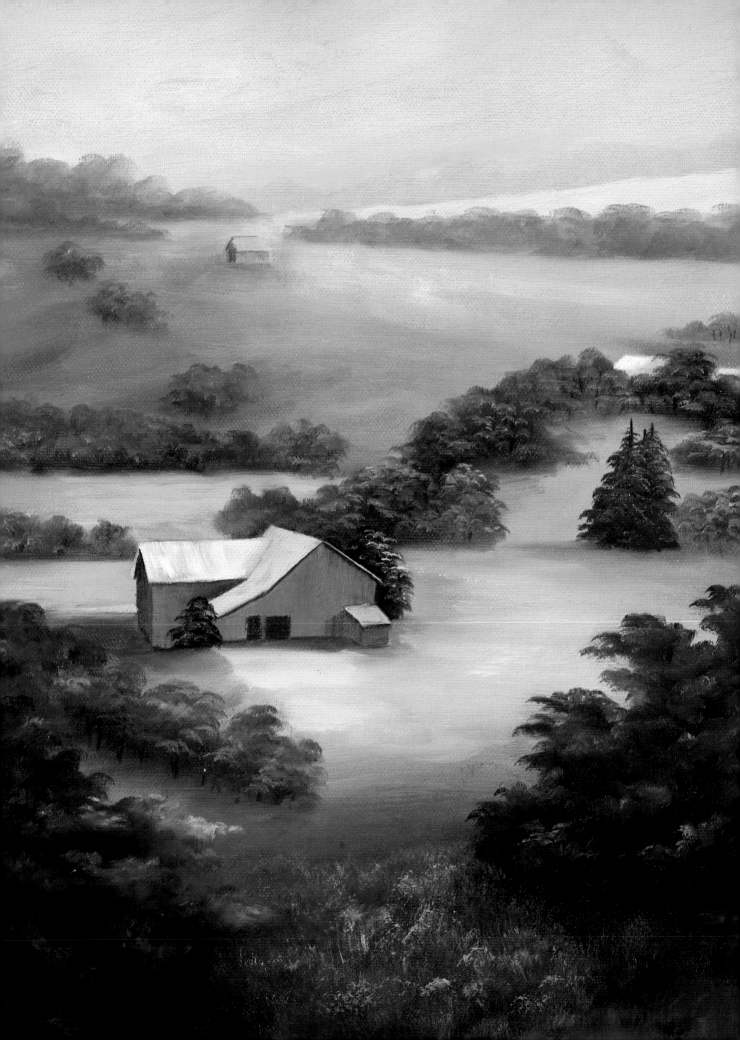

Valley Farmland

5

This landscape shows how to achieve a complete range of depth and distance while looking across a valley from a high point of view. There are several elements that contribute to this illusion of great distance. First: color and value. The red tones of the barns and the greens of the trees and fields become more subdued and lighter in value as they recede into the distance. Second: details. The buildings in the foreground and mid-range are painted with more detail than is the barn on the distant hillside. Third: relative size. Compare the sizes of the barns, the foliage on the trees and the size of the flowers in the foreground. To push the main barn into the mid-range, it must be painted relatively smaller than the foreground flowers. Finally: point of view. Looking down onto the barn roof allows the viewer to feel that the barn is sitting down in a valley and the viewer is on a foreground hill overlooking the valley.

ACRYLIC COLOR FOR UNDERCOAT

DecoArt Americana
"Orange Twist"

OIL COLOR MIXES

Peach mix

Light blue mix

Lavender blue mix

Medium green mix

Olive green mix

Blue-green mix

Yellow-green mix

Line Drawing

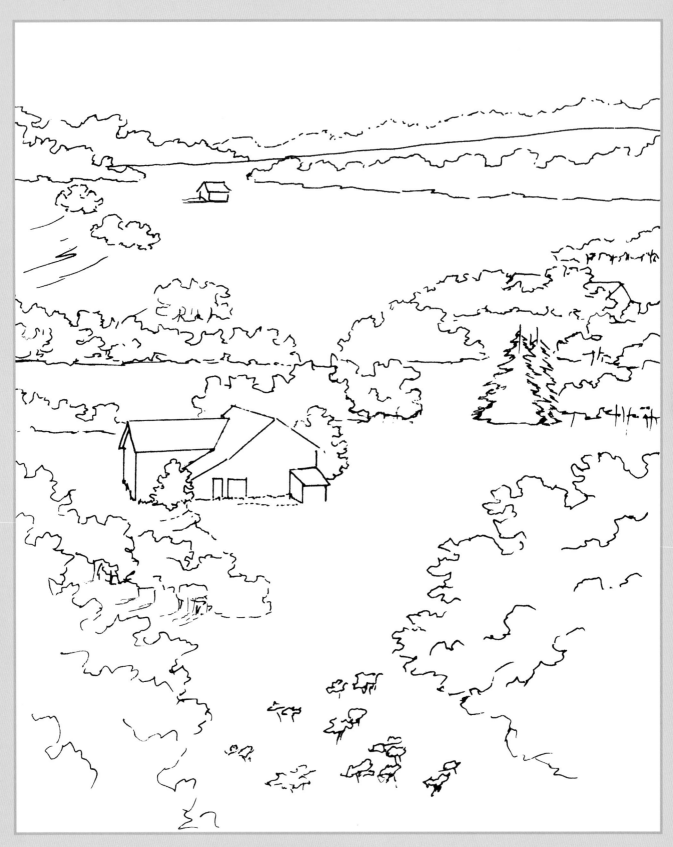

This drawing may be hand-traced or photocopied for personal use only.

Enlarge at 118% to bring it up to full size.

Surface
Stretched canvas, 16 x 12 inches
(41 x 30 cm)

Acrylic paint
DecoArt Americana "Orange Twist"

Oil paints
Permalba Professional Oil Colors.
Place the following bead-lengths on your palette:

Titanium White: 2¼ inches (57mm)

Cadmium Yellow Light: 1/8 inch (3mm)

Cadmium Yellow Medium: a touch

Naples Yellow: 1/4 inch (6mm)

Perinone Orange: 1/16 inch (1.6mm)

Cadmium Red Light: 1/16 inch (1.6mm)

Sap Green: 1½ inches (38mm)

Quinacridone Violet: 1/8 inch (3mm)

Phthalo Blue: 1/4 inch (6mm)

Raw Sienna: 1/8 inch (3mm)

Burnt Sienna: 1/8 inch (3mm)

Burnt Umber: 1/2 inch (13mm)

Ivory Black: 1/2 inch (13mm)

Oil color mixes
Use a palette knife to mix the following colors on your palette:

Peach mix: 1/3 inch (8.5mm) Titanium White + touch of Perinone Orange

Light blue mix: 1/3 inch (8.5mm) Titanium White + touch of Phthalo Blue + touch of Quinacridone Violet

Lavender blue mix: 1/8 inch (3mm) Titanium White + 1/8 inch (3mm) light blue mix + touch of Quinacridone Violet

Olive green mix: 1 inch (25mm) Sap Green + 1/2 inch (13mm) Ivory Black

Medium green mix: 1/4 inch (6mm) Sap Green + 1/4 inch (6mm) olive green mix + 1/4 inch (6mm) Titanium White

Blue-green mix: 1/4 inch (6mm) Phthalo Blue + 3/8 inch (10mm) Burnt Umber

Yellow-green mix: 1/4 inch (6mm) Sap Green + 1/4 inch (6mm) Titanium White

Brushes
2-inch (51mm) foam brush, 2-inch (51mm) soft bristle brush, nos. 8 and 10 stiff bristle flats, nos. 6 and 8 badger filberts, nos. 6 and 12 badger flats, large soft mop brush, no. 2 script liner

Other materials
Clear medium, gray graphite paper, tracing paper, paper towels, palette knife

Undercoat with Orange Acrylic, Transfer the Drawing and Apply Clear Medium
Cover the entire canvas with an even undercoat of orange acrylic paint using a 2-inch (51mm) foam brush. Let dry completely. Trace or photocopy the line drawing, enlarge to the percentage needed, and transfer to the canvas using gray graphite paper. Brush a sparing amount (less than 1 tablespoon) of the clear medium mix over the entire canvas using a 2-inch (51mm) soft bristle brush. Work it well into the canvas. Place a paper towel over the canvas and brush gently over the paper towel to pick up any excess medium. Proceed with the oil painting.

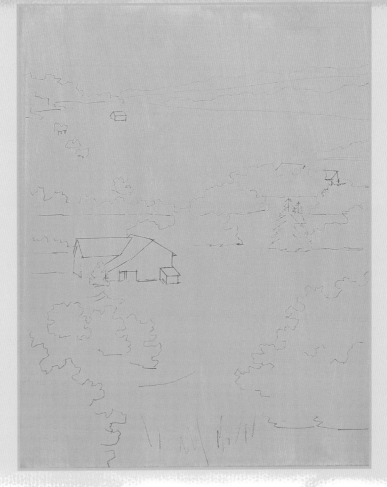

Step 1: Base In Sky Colors

With a no. 8 stiff bristle flat, apply a loose, somewhat mottled peach mix from the tree-tops upward, allowing the brush to run out of paint about two-thirds of the way to the top of the sky area. With light blue mix, transition from the top of the canvas down, blending somewhat where the two colors meet. With gentle diagonal strokes, create some color variations in the sky for interest.

Step 2: Tap In the Most Distant Trees

With lavender blue mix on a no. 6 badger filbert, suggest the most distant foliage with a light tapping stroke of the brush. Keep this light but allow some value changes to indicate depth in the trees. With the same filbert brush, sharpen some detail in the tree tops where they are silhouetted against the sky.

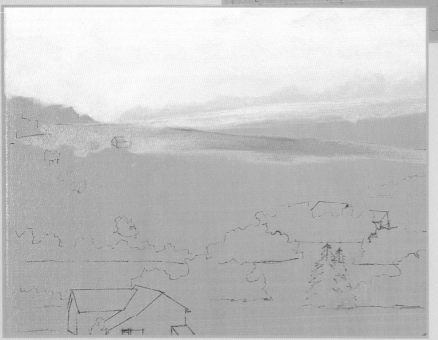

Step 3: Lay In Distant Fields

With a no. 12 badger flat, brush mix Titanium White and a touch of the medium green mix for a pale mint green. Lay in the most distant field at the top of the hill with long horizontal strokes. Continuing forward in the plane of the picture, lay in the next field, picking up more medium green mix on your brush for a slightly darker green. Paint around the little outbuilding.

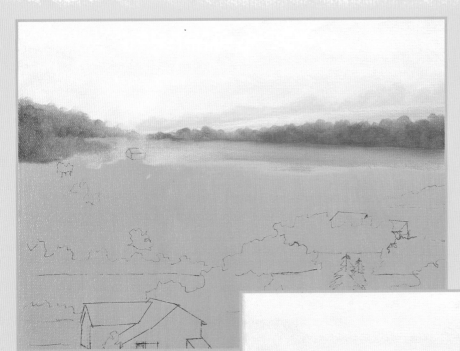

Step 4: Base In Background Treeline

Lighten some of the medium green mix with a little Titanium White and gray it down with a touch of Ivory Black. Using a no. 6 badger filbert, stroke in the base color of the row of green trees in the distance. Once the color is in place, add interest and value changes with the neutral stroke and a filbert brush. As you tap this grayed green color up into the peach of the sky on the left side, it will lighten along the tree tops and make these trees look as if they are in the far distance.

Step 5: Place Distant Grassy Field

With a no. 8 stiff bristle flat and the mint green brush-mix from step 3, gray this green down a tad more by adding a touch of Ivory Black to the mix. Continuing to come forward in the plane of the picture, place in the open grassy field in the distance, working the color to follow the lay of the land. Let some of the orange undercoat show through in some areas.

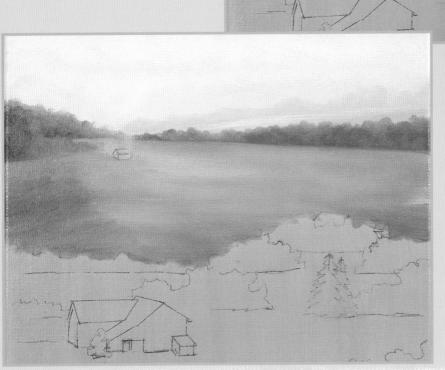

Step 6: Enrich and Highlight Field

To enrich the color and give an earthy look to this distant field (so it looks like real farmland and not a golf course!), work in touches of medium green mix and Raw Sienna here and there. With a brush mix of Naples Yellow and Titanium White, highlight the highest parts of the field. Mop lightly with a soft mop brush to blend and soften the textures.

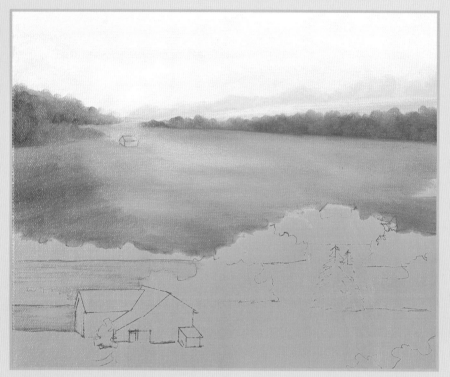

Step 7: Base In Plowed Fields

With a no. 12 badger flat, brush-mix Raw Sienna and Titanium White and base in the plowed fields to the left of and behind the main barn in the mid-ground. Keep this layer of color fairly thin so the orange undercoat shows through here and there. Avoid painting over the barn and the trees in that area, but do tuck this basecoat up tight to the barn.

Step 8: Add Long Rows

With the same brush and the Naples Yellow/Titanium White mix from step 6, use the chisel edge of the brush and horizontal motions to indicate rows in the plowed fields. Keep this detail very minimal.

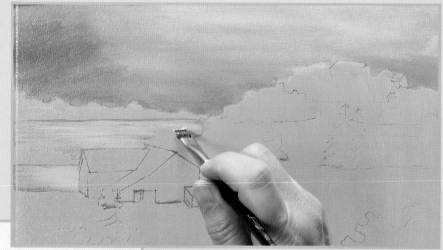

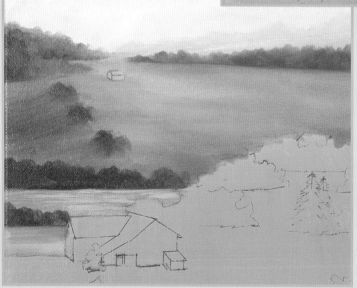

Step 9: Tap in Trees in Mid-ground

With a no. 8 badger filbert and the same grayed-green mix from step 4, use the neutral stroke to tap in the lines of trees behind and between the plowed fields. Also tap on the three individual trees in the distant field, letting them get progressively darker as they come forward.

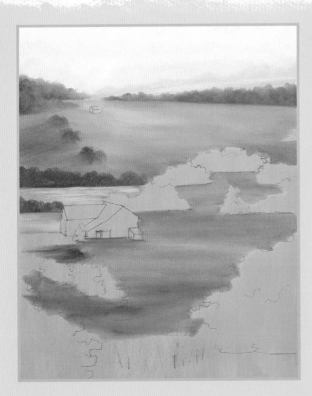

Step 10: Begin Grassy Mid-ground Fields

With a brush-mix of the medium green mix and Titanium White, place in the grassy fields to the right of the barn and coming forward, using horizontal strokes of the no. 8 bristle flat to indicate the flat contours of the land.

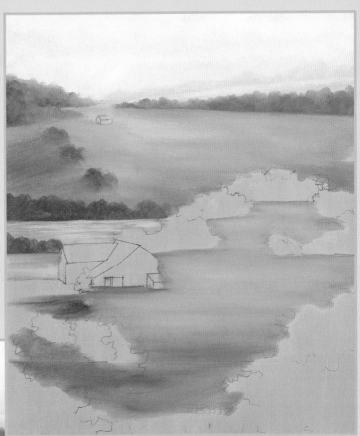

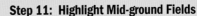

Step 11: Highlight Mid-ground Fields

Using a no. 8 filbert and a brush-mix of Naples Yellow and Titanium White, indicate highlights and lighter grasses in the more distant parts of this mid-ground field, then switch to the larger no. 8 bristle flat for the wider areas of the field coming forward. Since this land is fairly flat, your strokes should be mostly horizontal.

Step 12: Add Darker Mid-ground Trees

With both the olive green mix and the medium green mix in the no. 8 filbert, use the neutral stroke to tap on the trees that surround the mid-ground fields as well as the more distant little grove of trees coming in from the right. This is not a thick application of paint; you still want bits of the orange under-coat to show through here and there. For the darker trees in this area, pick up a little bit of the blue-green mix on your brush and tap on the foliage using the neutral stroke.

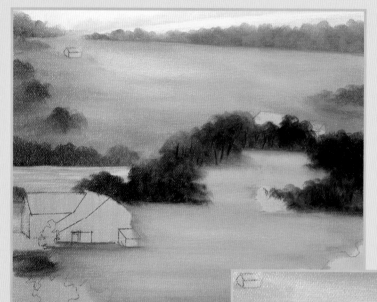

Step 13: Detail the Mid-ground Trees

Wipe out the filbert brush on a clean paper towel and tap the flat side along the bases of the trees to indicate cast shadows and to set the trees into the ground. With a soft mop brush, barely touch the foliage of these trees to soften some of the textures. Indicate some tree trunks in among the mass of the foliage using a no. 2 script liner and the olive green mix or the blue-green mix, thinned with a tiny amount of clear medium.

Step 14: Highlight the Foliage

With the no. 6 filbert, lightly touch subtle highlights of Naples Yellow onto the tops of the trees where the sunlight warms the color of the foliage. Wipe the brush on a paper towel before you go back and pick up more paint so your application remains very light in most areas. Pick up a tiny touch of Cadmium Yellow Medium on your dirty brush to strengthen the highlights in a few spots. These will be just on the outermost branches where the sunlight is the strongest. Be sure to leave most of your original greens showing so you do not lose the depth and shadows of the foliage.

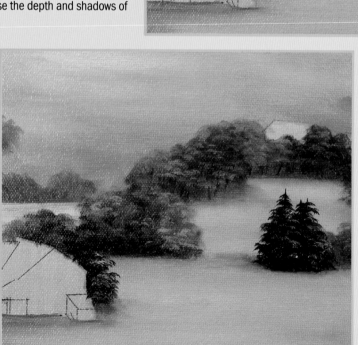

Step 15: Paint the Evergreens

The evergreens in the mid-ground field and the tree to the right of the barn are based in with the olive green mix and the blue-green mix, a little heavier on the blue-green. Highlight the evergreens with very light touches of the light blue mix; highlight the tree next to the barn with Naples Yellow and a final spark of Cadmium Yellow Light.

Landscape Lesson #5: Achieving Depth from a High Point of View

When a landscape painting has an unusual point of view, such as this one where the viewer is looking down at open farmlands in a wide and expansive valley, correct use of colors and values will suggest both depth and distance. In the value study below, you can clearly see how the colors of the trees become a duller, grayed-down green and the values become lighter the further out you go. Compare this value study to the finished painting to see how well this concept works to suggest great distance. Another key technique is the placement of the trees. Note that the treelines are angled in the shape of a "V" with the wide end opening up to the distant background and the narrow end pointing toward the viewer. This angle also leads your eye into the distance.

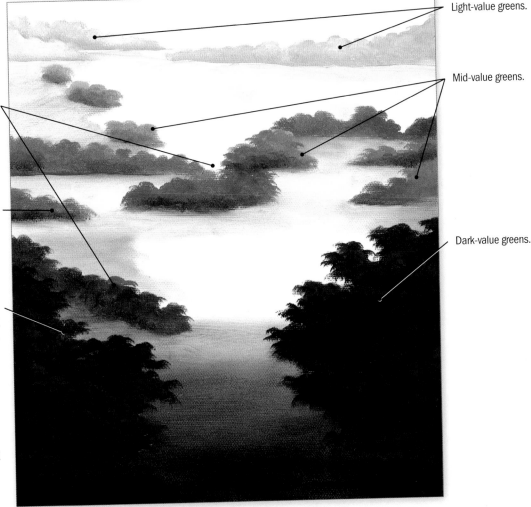

Light-value greens.

Mid-value greens.

Dark-value greens.

The V-shaped angles of these treelines lead your eye into the distance.

Softer highlights and less contrast set these trees into the mid-ground.

Stronger highlights and more contrast bring these trees forward.

Point of View
Looking down onto the tree tops from a high point of view supports the illusion that the trees are in a valley. Don't add detailed trunks to the trees—that would confuse the viewer and destroy the illusion.

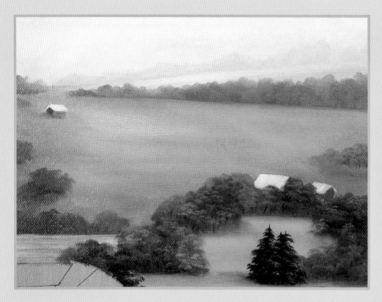

Step 16: Paint the Distant Barns and Outbuilding

The walls of the small outbuilding in the distant field and the two barns behind the mid-ground trees are based in with a brush mix of Burnt Sienna + Titanium White on a no. 6 badger flat. The roofs are painted with the light blue mix plus Titanium White. Shade under the distant outbuilding to set it into the ground.

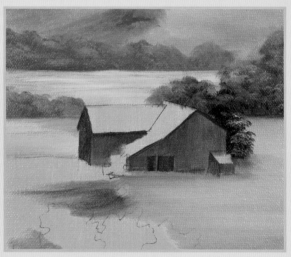

Step 17: Begin the Large Red Barn

The large barn in the valley is based in with a brush mix of Raw Sienna, Burnt Sienna and a touch of Cadmium Red Light. Stroke vertically with a no. 6 flat to suggest board lines and vary the color to give it a weathered look. The shadowed ends of the barn are the same mix but with a little Burnt Umber added. Outline the eaves with Burnt Umber on the chisel edge of the brush. The doors are also Burnt Umber.

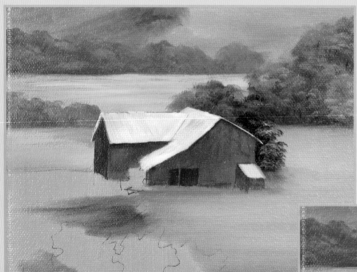

Step 18: Paint the Barn Roof

The roof is based in with the light blue mix where it faces left; where the roof faces forward, pick up Titanium White on the dirty brush and base this section in. Each roof section gets a touch of Burnt Sienna to give it a slightly rusted look. Stroke in the direction of the roofline. To give an edge to the roofline, use the roof colors on the chisel edge of the flat.

Step 19: Shade, Highlight and Add Details

Finish the barn with highlighting and shading. Place the little tree in the corner with olive green mix and blue green mix, then highlight with touches of medium green. Shade the ground to the left of the barn, and in the corner where the little shed meets the main barn, with the olive green mix. Shade the barn walls in this area with a touch of Burnt Umber.

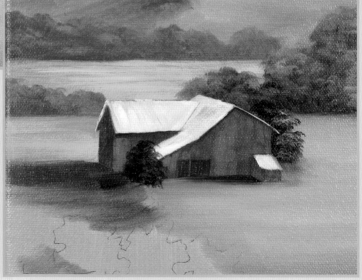

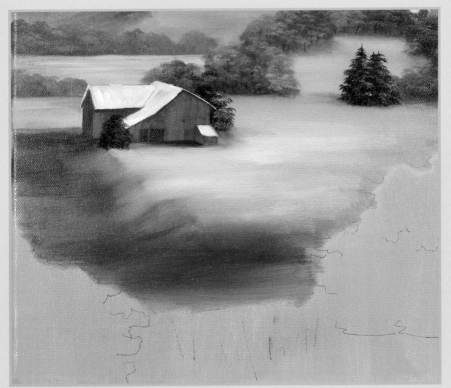

Step 20: Paint Grassy Field

Working your way forward in the plane of the picture, begin laying in the darker green grass areas on the left side and center using the olive green mix. Highlight the brightest field area in front of the barn with a brush mix of Cadmium Yellow Light and Titanium White.

Step 21: Add Trees to Left of Barn

The trees in the valley to the left and in front of the barn are based in with the neutral stroke and a combination of the olive green mix and the blue-green mix to make a dark green. Add the suggestion of trunks with the same dark green, but use a no. 2 script liner. Highlight some of the foliage with Naples Yellow tapped on with the chisel edge of the no. 6 filbert. If you need additional highlighting, use a minimal amount of Cadmium Yellow Light and let it blend a little with the underlying greens.

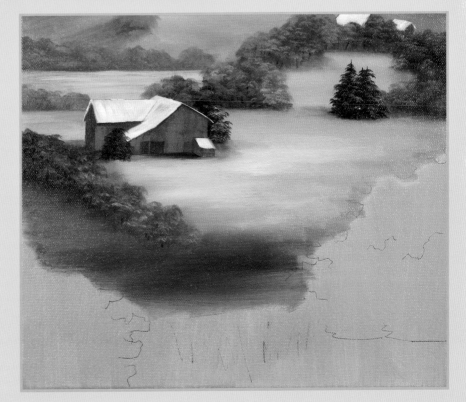

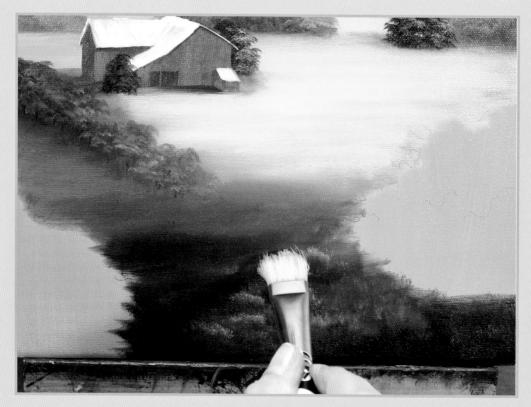

Step 22: Foreground Grasses

Place in the darkest foreground grass areas using the dark green combination of olive green and blue-green, heavier on the blue-green. To indicate the grass blades in the nearest foreground, use a no. 10 stiff bristle flat and a little bit of Cadmium Yellow Light on the tips of the bristles. Drop the brush handle down, then push into the canvas with the bristles. Some of the bristles will spring up, some will bend downward. Just touch and release—don't stroke. This gives you the look of tufts and blades of grasses.

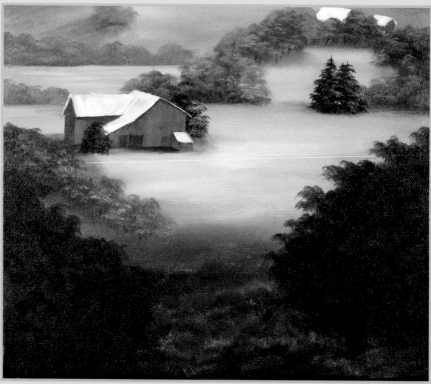

Step 23: Base In Closest Shrubs

The large, dark shrub on the left is based in with the blue-green mix. The shrub on the right is based in with the blue-green mix, then deepened with Phthalo Blue and Quinacridone Violet for darker values in the main body of the shrub.

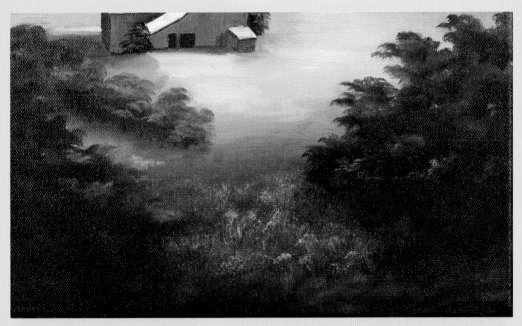

Step 24: Add Foreground Wildflowers

Highlight the left shrub with touches of Cadmium Yellow Light, and the shrub on the right with medium green mix, then a few touches of yellow-green mix. Gently mop all the foliage to soften textures using a small mop brush. Add a few wildflowers in the center foreground with a mix of Perinone Orange and Cadmium Yellow Medium. Brighten the highlight in the field in front of the barn with a mix of Cadmium Yellow Light and Titanium White.

Step 25: Final Touches

If the outbuilding in the far distance is too noticeable, set it back by graying down the colors of the roof and walls. I darkened the doorways of the large red barn to add contrast to the red walls, and I touched on some brighter yellow highlights in the foreground shrubs to contrast with the dark green foliage. Remember: foreground elements should always have much more contrast, brighter colors, and more details than distant elements.

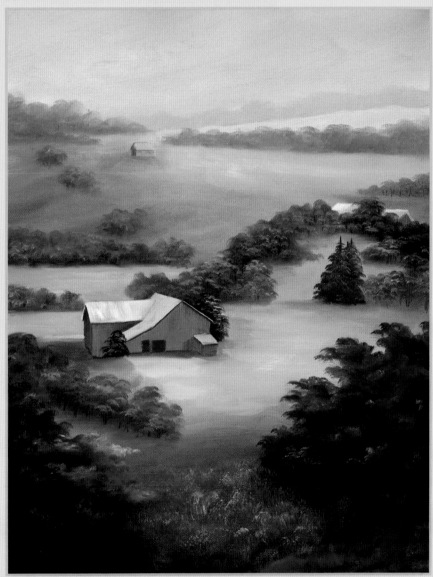

High Valley Summer

The largest, most dominant element in this painting is the tallest mountain near the center. To make this huge object appear as if it is in the distant background, keep the values close to the value of the sky, soften all edges and keep details very subtle and hazy. The more atmosphere between you and the mountain, the hazier it will appear. The other mountains appear to come forward as they are painted with deeper values, more detail and rugged textures. The very small trees at the base of the mountains contrasting with the mid-range trees and finally the very large foreground trees also give the viewer a sense of great depth of field.

OIL COLOR MIXES

Peach mix

Light blue mix

Shadow blue mix

Purple-gray mix

Olive green mix

Blue-green mix

Line Drawing

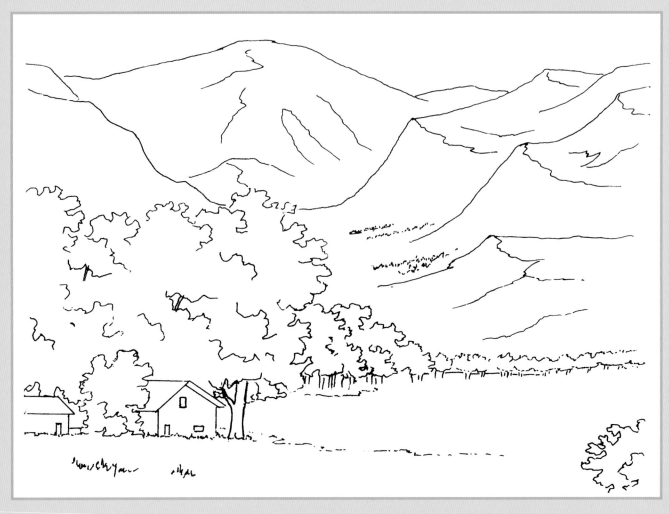

This drawing may be hand-traced or photocopied for personal use only.
Enlarge at 149% to bring it up to full size.

Surface

Stretched canvas, 12 x 16 inches (30 x 41 cm)

Oil paints

Permalba Professional Oil Colors. Place the following bead-lengths on your palette:

Titanium White: 1¾ inches (44mm)

Cadmium Yellow Light: 1/16 inch (1.6mm)

Cadmium Yellow Medium: 1/8 inch (3mm)

Naples Yellow: 1/4 inch (6mm)

Perinone Orange: 1/16 inch (1.6mm)

Quinacridone Violet: 1/2 inch (13mm)

Phthalo Blue: 1/4 inch (6mm)

Sap Green: 1/2 inch (13mm)

Burnt Umber: 3/8 inch (10mm)

Ivory Black: 3/8 inch (10mm)

Oil color mixes

Use a palette knife to mix the following colors on your palette:

Peach mix: 1/2 inch (13mm) Titanium White + touch of Perinone Orange

Light blue mix: 1/2 inch (13mm) Titanium White + touch of Phthalo Blue + touch of Quinacridone Violet

Shadow blue mix: 1/16 inch (1.6mm) Phthalo Blue + 1/8 inch (3mm) Ivory Black + 1/4 inch (6mm) Quinacridone Violet

Purple-gray mix: 1/2 inch (13mm) Titanium White + 1/8 inch (3mm) Ivory Black + 1/8 inch (3mm) Quinacridone Violet

Olive green mix: 3/8 inch (10mm) Sap Green + 1/8 inch (3mm) Ivory Black

Blue-green mix: 1/8 inch (3mm) Phthalo Blue + 3/8 inch (10mm) Burnt Umber

Brushes

2-inch (51mm) soft bristle brush, nos. 8 and 10 stiff bristle flats, nos. 6 and 8 badger filberts, no. 6 badger flat, large soft mop brush, no. 1 script liner

Other materials

Clear medium, gray graphite paper, tracing paper, paper towels, palette knife

Transfer the Line Drawing and Apply Clear Medium

Trace or photocopy the line drawing, enlarge to the percentage needed, and transfer to the canvas using gray graphite paper. Make sure the lines show up well. Brush a sparing amount (less than 1 tablespoon) of the clear medium mix over the entire canvas using a 2-inch (51mm) soft bristle brush. Work it well into the canvas. Place a paper towel over the canvas and brush gently over the paper towel to pick up any excess medium. Proceed with the oil painting.

Landscape Lesson #6: Setting High Mountains into the Distance

Paintings of mountainous landscapes can be very strong, forceful and dramatic, especially when every ridge and rocky crag is as sharply detailed and richly colored as the rest of the painting. But realistically, most high mountains are viewed through the haze of the intervening atmosphere. The more distant they are or the higher they are, the hazier they can appear, unless the air is exceptionally crisp and clear. In landscape painting you can use this haziness to your advantage to help suggest relative distance. Along with value and color changes, the lack of detail is one of the key ways you can use to imply great distance in your painting, especially if you are dealing with something as huge as mountains.

Mid values, darker colors, and some detail bring this mountain closer to the viewer.

Lightest values and least detail show that this mountain is farther in the distance than any other.

Haziness, soft edges

Ridgelines are sharper, details are more visible, colors are darker and there is more contrast between the lighter and darker values.

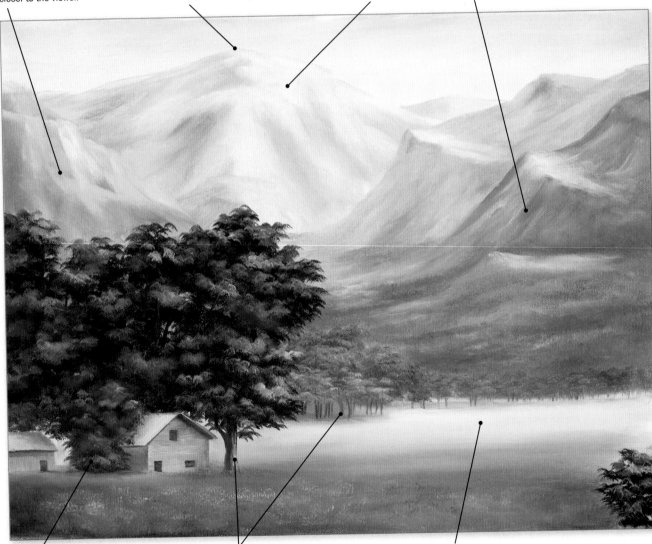

Darkest values and most detail tells you that this area is in the foreground.

Compare smaller overall size of mid-ground trees with larger size of foreground trees.

Lack of shadows in the sunlit areas of the field allows stronger focus on the detailed areas of the foreground trees, buildings and grasses.

Step 1: Base In Light Value Sky Colors

With a no. 10 stiff bristle flat, work peach mix into the lower sky area. Wipe out the brush and work the light blue mix into the upper sky area. Blend these two sky colors where they meet, and work the colors to give a soft, hazy, look to the sky.

Step 2: Begin Most Distant Mountains

Base in the tallest, most distant mountains with the light blue mix on a no. 10 bristle flat, stroking in the direction of the steep, angular slopes. Keep this value very light and let the white of the canvas show through in places.

Step 3: Define Shadows and Ravines

With the shadow blue mix and the same brush, establish the shadowed areas and deep ravines on the slopes of the mountain, again stroking in the direction of the steep slopes you already placed in the previous step.

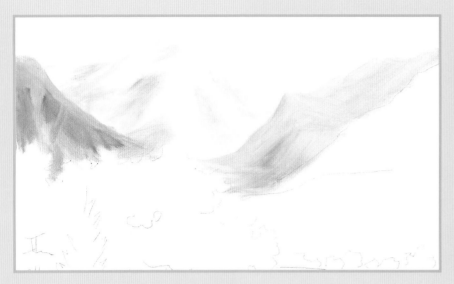

Step 4: Base In Mid-range Mountains
Base in the mid-range mountain on the right with a brush-mix of equal parts shadow blue mix and purple-gray mix, stroking in the steep angular slopes with the bristle flat. Highlight the surfaces that face upward with the light blue mix. Base in the mountain on the left with the brush-mix of shadow blue and purple-gray, but this time go a little heavier on the purple-gray.

Step 5: Base in Closest Mountain
Base in the closest mountain on the right with the purple-gray mix and carry this color down and to the left into the more gentle slopes of the valley, picking up some light blue mix as you stroke in the valley.

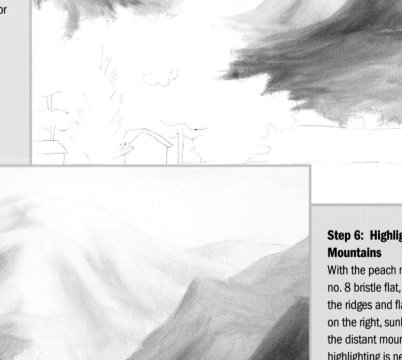

Step 6: Highlight Distant Mountains
With the peach mix on a no. 8 bristle flat, highlight the ridges and flat planes on the right, sunlit side of the distant mountains. If any highlighting is needed on the shadow side, brush-mix light blue mix + Titanium White for this highlight color.

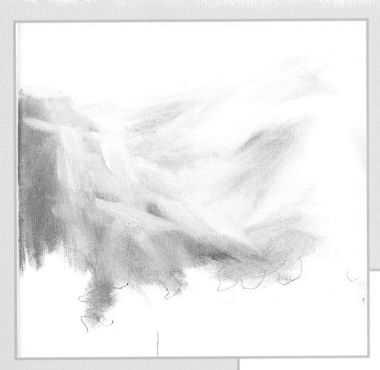

Step 7: Highlight Mountain on Left
With the peach mix on a no. 8 bristle flat, highlight the ridges and flat planes on the right, sunlit side of the mountain on the left side, stroking in the direction of the angles of the slopes.

Step 8: Highlight Mid-range Mountain on Right
Since most of this mountain is in shadow (the direction of the sun is from upper right), highlight sparingly with a cool white brush-mix of light blue and Titanium White. Any flat planes or ridges that face the light are high-lighted with a sparing amount of peach mix.

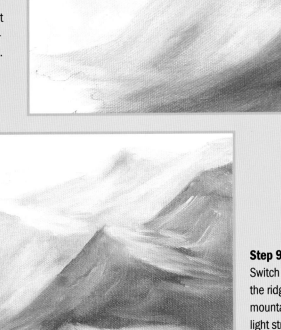

Step 9: Highlight Closest Mountain
Switch to a no. 24 badger flat and highlight the ridges and flat planes of this closest mountain with the peach mix where the sun-light strikes them. With light blue, add cool highlights along the slopes of the shadowed side, and where the slope becomes a valley.

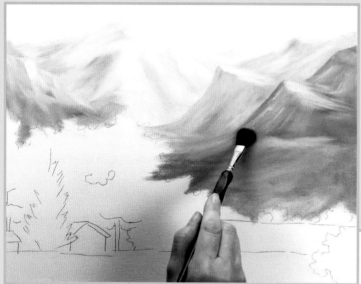

Step 10: Soften and Blend Textures
With a large soft mop brush, lightly soften and blend the mountain textures and colors, mopping in the direction of the terrain and barely touching the mop bristles to the canvas. Wipe your brush on a paper towel often so you don't transfer color.

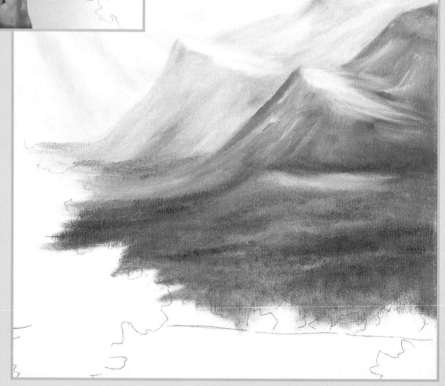

Step 11: Suggest Drifts of Trees
Make a brush-mix of the shadow blue mix, purple-gray mix and a touch of the olive green mix. Using the chisel edge of the no. 24 badger flat, pick up a sparing amount of this brush-mix and bounce the bristles on the canvas to suggest very distant, very faint trees drifting down the slopes of the mountain valleys.

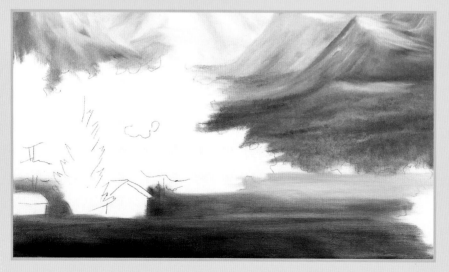

Step 12: Place Foreground Field
With a brush-mix of Naples Yellow and Titanium White, pick up a tiny bit of olive green mix on a no. 8 bristle flat and stroke in the light green field in the middle distance. As you come forward in the field, pick up more blue-green mix on your brush and work it in with horizontal strokes of the chisel edge. Avoid painting over the cabins and the foreground trees.

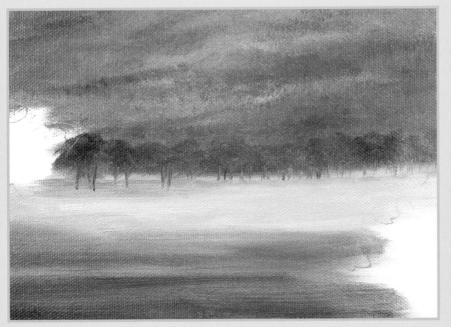

Step 13: Tap In Mid-ground Trees

The trees along the far edge of the open field are tapped in with a brush-mix of the light blue and blue-green mixes on a no. 6 filbert. Soften the base of this line of trees to create the shaded area under the trees. Place in the tree trunks with a no. 1 script liner and the same green brush-mix.

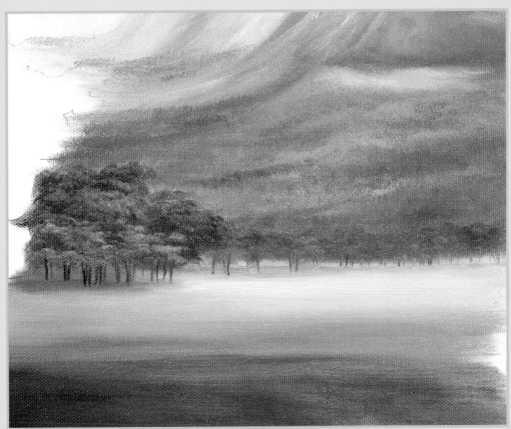

Step 14: Paint Mid-ground Trees in Center

Using olive green on a no. 6 filbert, tap in the shapes of the group of shorter trees in the mid-ground center of the painting. Pick up a touch of blue-green mix and shade under these trees. Line in the tree trunks with olive green on a no. 1 liner. Shape and highlight the foliage with Naples Yellow on a no. 6 filbert, tapping it on using the chisel edge of the brush. Use the same brush and color to highlight the line of trees you painted in the previous step. The lightest highlights on the foliage are touches of Cadmium Yellow Medium.

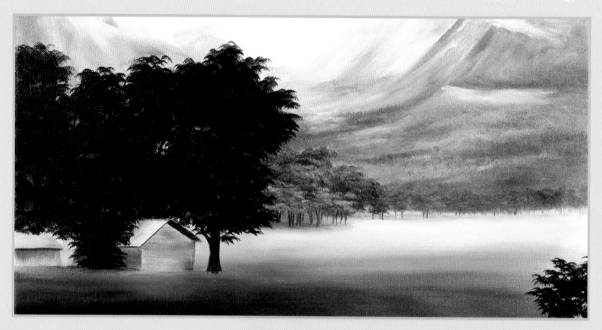

Step 15: Begin Buildings and Large Foreground Trees

Base in the light side of the larger cabin with a brush-mix of light blue plus a touch of Ivory Black for a weathered gray tone. Add a touch more black to the mix and paint the shadowed side. Pick up Titanium White on the dirty brush and base in the roof. Base in the shadowed side of the smaller building with a brush-mix of purple-gray plus a touch of black. Add Titanium White to the dirty brush and base in the lighter side of this building. The roof is painted with light blue on the dirty brush. Base in the background area of the foreground trees with olive green mix on a no. 8 bristle flat. Place in the large foreground tree trunks and branches with a brush mix of blue-green, Ivory Black and light blue. With blue-green mix on the no. 8 filbert, tap on clusters of foliage on the large, dark trees, plus the bushes between the buildings and at the far right of the painting. Allow hints of the background color to show through in all these areas.

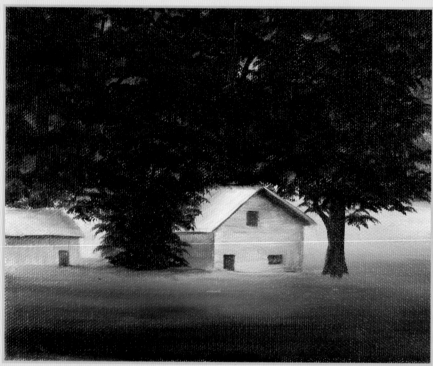

Step 16: Highlight and Shade Buildings

Highlight the roof on the larger cabin with Titanium White, and highlight the roof on the little building with light blue mix, using a no 6 flat. Shade the roofs with a little black where the trees cast shadows on them. The doors and windows are placed in with a brush-mix of purple-gray and Ivory Black. Highlight the front walls of the buildings with a little peach mix, then with a tiny amount of Perinone Orange. Suggest clapboards with horizontal motions of the chisel edge of your brush.

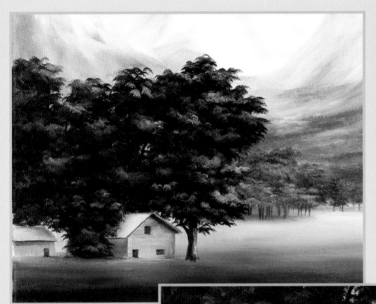

Step 17: Highlight Trees and Bushes

Highlight all the tree and bush foliage first with Naples Yellow on the no. 6 filbert, using a tapping motion of the chisel edge. The final highlights in the brightest sunlit areas are tapped on with Cadmium Yellow Light. Highlight the right side of the large tree trunk with peach mix on the chisel edge of the flat brush. When all highlights are in place, mop gently with a large soft mop brush to knock back some of the foliage textures.

Step 18: Tap On Foreground Grasses

Brush-mix olive green mix + Cadmium Yellow Light and begin tapping in the grassy textures of the closest foreground fields at the bottom of the canvas. Pick up more yellow sometimes for the lighter grasses.

Step 19: Final Details

Soften and blend out the lightest green field to suggest haziness in the valley. Highlight the small bush in the lower right corner with the same brush mix used in step 18. Tap on a few more faint trees on the far distant slopes of the darkest mountain to help define the planes and separate the lower ridges.

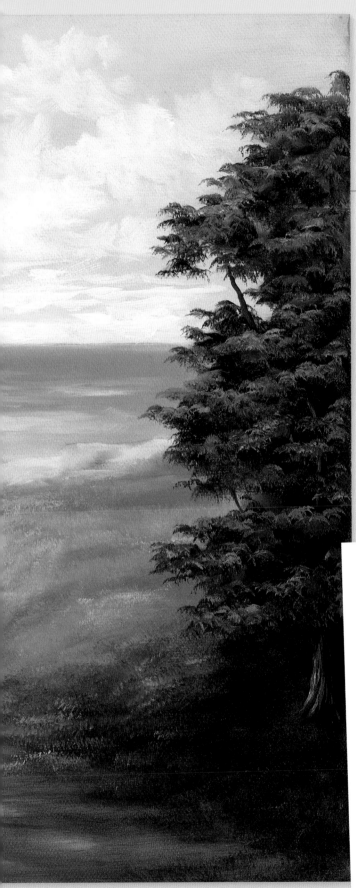

Ocean View

To achieve a feeling of real distance across a great body of water, control the size and shape of the waves as well as the size and shape of the clouds. Water in the distance, where it is deeper, usually will appear calmer with little activity. The closer the water comes to shore, the more active the water will become, forming waves, sea foam, shimmers, etc. With the clouds, the higher in the sky, the larger the cloud formations will appear. As they recede toward the distant horizon, the clouds become more linear and the value and color become more subtle. In this painting, depth is achieved even further by the addition of the path, trees, rocks and grasses. All lead the viewer to the shore ready to gaze upon the ocean beyond.

ACRYLIC COLOR FOR UNDERCOATING

DecoArt Americana
"Orange Twist"

OIL COLOR MIXES

Sky blue mix Peach mix Warm white mix
Deep water blue mix

Dark gray-purple mix Dark green mix Medium green mix

Line Drawing

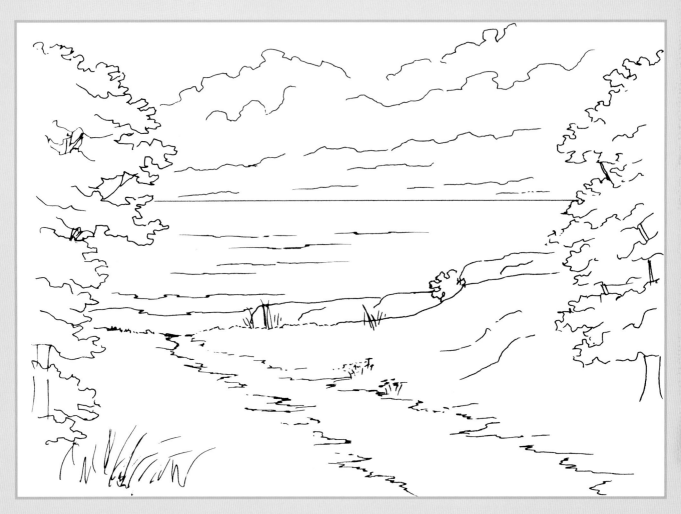

This drawing may be hand-traced or photocopied for personal use only.
Enlarge at 147% to bring it up to full size.

Surface

Stretched canvas, 12 x 16 inches
(30 x 41 cm)

Acrylic paint

DecoArt Americana "Orange Twist" or other
medium orange acrylic paint

Oil paints

Permalba Professional Oil Colors.
Place the following bead-lengths on your
palette:

Titanium White: 1¼ inches (32mm)

Cadmium Yellow Light: 1/8 inch (3mm)

Naples Yellow: 1/8 inch (3mm)

Perinone Orange: 1/8 inch (3mm)

Cadmium Red Light: 1/16 inch (1.6mm)

Phthalo Blue: 1/2 inch (13mm)

Quinacridone Violet: 1/16 inch (1.6mm)

Sap Green: 1-1/16 inches (26.6mm)

Burnt Sienna: 1/8 inch (3mm)

Ivory Black: 1/2 inch (13mm)

Oil color mixes

Use a palette knife to mix the following colors
on your palette:

Sky blue mix: 1/2 inch (13mm) Titanium
White + 1/16 inch (1.6mm) Phthalo Blue +
speck of Quinacridone Violet

Peach mix: 1/2 inch (13mm) Titanium White
+ touch of Perinone Orange

Warm white mix: 1/4 inch (6mm) Titanium
White + touch of Naples Yellow

Deep water blue mix: Sky blue mix + touch of
Quinacridone Violet + speck of Ivory Black

Dark purple-gray mix: Quinacridone Violet +
touch of Ivory Black + touch of sky blue mix

Dark green mix: 1 inch (25mm) Sap Green
+ 1/3 inch (8.5mm) Ivory Black + 1/8 inch
(3mm) Phthalo Blue

Medium green mix: 1/3 inch (8.5mm) Tita-
nium White + 1/4 inch (6mm) dark green mix

Brushes

2-inch (51mm) foam, 2-inch (51mm) soft
bristle craft brush, nos. 8 and 10 stiff bristle
flats, no. 6 badger filbert, nos. 12 and 24
badger flats, no. 1 script liner, large soft
blending mop

Other materials

Clear medium mix, gray graphite paper, trac-
ing paper, paper towels, palette knife

CANVAS PREPARATION

After you have applied an orange acrylic
undercoat and transferred the drawing to the
canvas, brush a sparing amount (less than
1 tablespoon) of the clear medium mix over
the entire canvas using a 2-inch (51mm)
soft bristle brush. Work it well into the canvas.
Place a paper towel over the canvas and
brush gently over the paper towel to pick up
any excess medium. Proceed with the oil
painting.

Undercoat with Orange Acrylic and Transfer the Drawing

Cover the entire canvas
with an even undercoat of
orange acrylic paint using a
2-inch (51mm) foam brush.
Let dry completely. Trace or
photocopy the line drawing,
enlarge to the percentage
needed, and transfer to the
canvas using gray graphite
paper. Make sure the lines
show up well. Brush with
clear medium following the
instructions under "Canvas
Preparation" above.

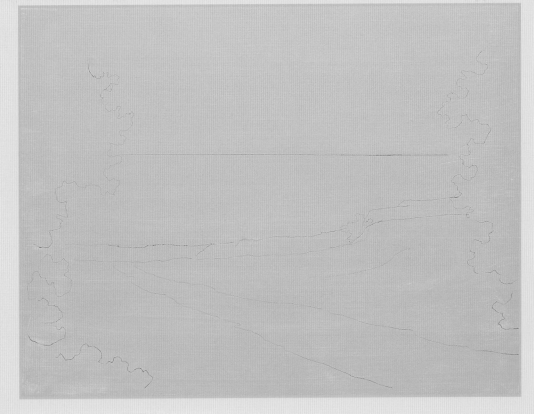

Step 1: Block In Blue Sky
Pick up sky blue mix on a no. 10 stiff bristle flat brush. Pick up touches of Phthalo Blue and Quinacridone Violet on the brush and loosely place this color into the upper sky area, working around the cloud patterns.

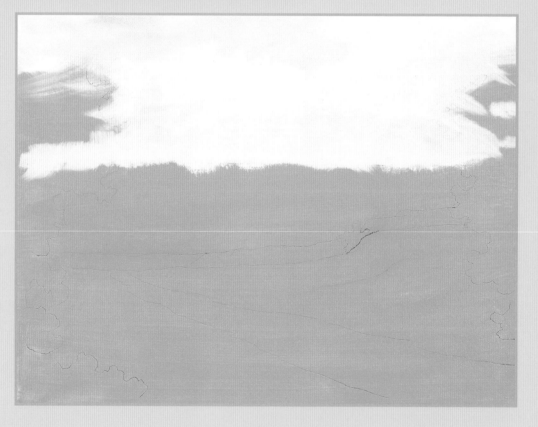

Step 2: Add Peach Glow
Pick up some peach mix on a clean no. 10 stiff bristle flat and block in the glow in the sky, allowing it to blend slightly with the sky blue color. Don't overwork it—we will soften and blend these later after the clouds have been placed.

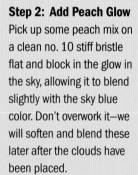

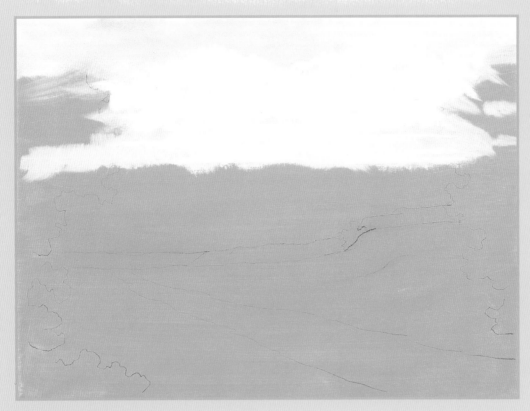

Step 3: Tap On Puffy Clouds

With a clean no. 24 badger flat, pick up some warm white mix and loosely tap on the puffy cloud shapes. As the clouds recede into the distance, level them out and make them more horizontal near the horizon line. Brighten the tops of some of the puffy clouds with thicker textures of warm white.

Step 4: Soften Cloud Edges

With a large, soft mop brush, gently mop the puffy clouds to soften the edges. Always mop into the cloud, not outward from the cloud. Mop the lower clouds near the horizon line with horizontal motions of the brush.

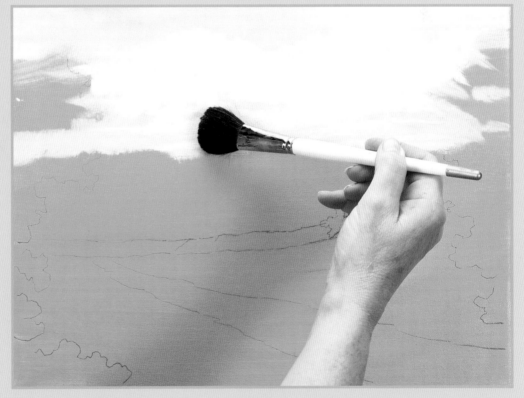

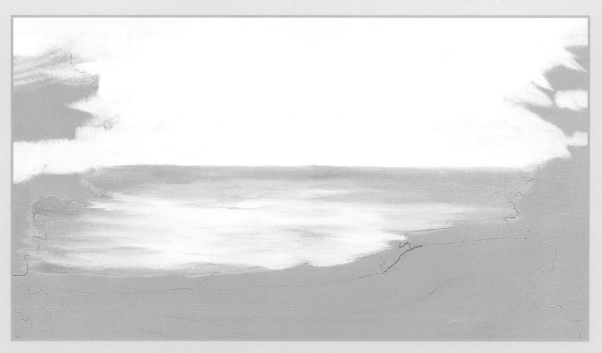

Step 5: Block In the Ocean Colors

Use a no. 24 badger flat and the deep water blue mix to establish the most distant ocean horizon line. This is a rather dark blue, but remember that the deeper the water, the darker the color. When this color is in and the horizon line is as straight as you can make it, softly mop laterally along this line with a large mop brush to remove any ridges of paint. Bring this color forward toward the shoreline using horizontal strokes of the no. 24 flat. As the water gets shallower, pick up more sky blue mix to lighten the color. Don't overblend—streakiness is good! And if some of the orange undercoat shows through, that's good too.

Landscape Lesson #7: Creating Distance in Ocean Scenes

The horizon line in "Ocean View" where the ocean meets the sky appears to be in the far distance for two main reasons:

1. the variation in the size and shapes of the clouds;
2. the relative activeness of the waves in the water.

Simply put, the closer the waves are to shore, the more active they are and the more whitecaps you'll see. The further out you look toward the horizon, the smaller the waves and the fewer whitecaps you'll see. The same with the clouds: the higher in the sky they are, the puffier they are. The lower, or closer to the horizon line they are, the more linear they appear. Clouds that lay very low to the horizon line make the horizon appear even more distant.

WRONG

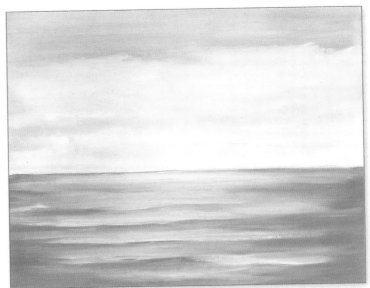

- Clouds are about the same size from the top of the painting all the way down to the horizon line.
- The cloud shapes never vary—they are all rounded and puffy.
- The waves in the distance are just as big, white, and active as the waves close to shore.

Step 6: Create Distant and Mid-range Waves

Switch to a no. 12 badger flat, pick up a sparse amount of sky blue mix on the chisel edge and lightly touch the bristles to the ocean area, pulling left and right to create distant waves. As you get closer to the shallower water near the shore, pick up Titanium White on the chisel edge and bounce the brush slightly as you draw the horizontal line of the waves. This creates the "curl" of the wave as it rolls over.

Step 7: Paint the Waves Closest to Shore

For the waves closest to the shore, bounce your brush a little bit more so the bristles bend slightly—this will lay more white paint down and suggest larger, more active waves. When all the waves are placed in, mop the area very gently, just enough to smooth them down slightly so they look part of the water and not just laying on top.

RIGHT

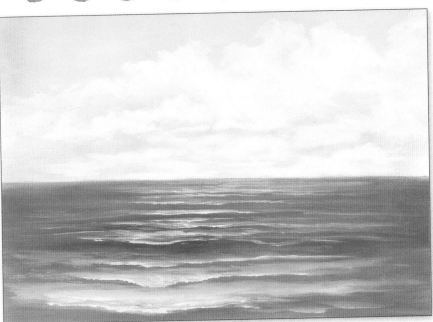

- Clouds vary in size and shape—puffier toward the top, more linear near the horizon line.

- Clouds that lay low to the horizon line make it look even more distant.

- Waves and water movement decrease in size and activity as they get further away.

- Waves near the shore are painted as whitecaps and foam.

97

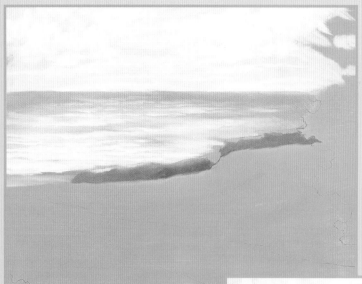

Step 8: Lay In Sandy Beach and Base of Boulders

Brush-mix Burnt Sienna, Naples Yellow and a little touch of Titanium White to make a "wet sand" color. With a no. 12 badger flat, use short strokes to lay in the color in the sandy beach next to the water. As you come forward, you can lay in a little warm white mix to lighten the sand color where it is drier. Pick up some Titanium White and tap in a wave or two that is rolling up over the wet sand.

Using the dark gray-purple mix, base in the darkest color on the boulders down to the ground, avoiding the tops of the rocks which will be highlighted later.

Step 9: Highlight Tops of Boulders

With the peach mix on a clean no. 12 badger flat, highlight the tops of the boulders with deliberate, painterly strokes that follow the rough angles and edges of the rocks. Blend the rock colors just slightly using a soft mop brush. Don't overblend—these rocks are rugged, not smooth. We will come back and add final highlights and details later.

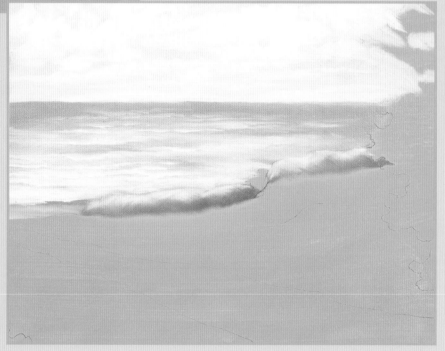

Step 10: Tap On Little Bush

Pick up medium green mix on a no. 6 badger filbert and tap on the little bush that is peeking up between the two large boulders. Shade the bottom with a touch of dark green mix, and highlight with a few touches of Naples Yellow.

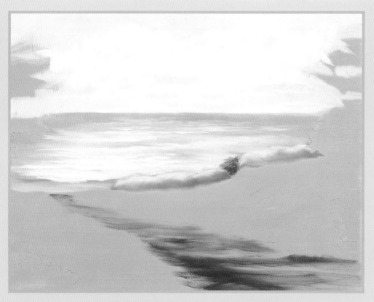

Step 11: Begin Dirt Pathway

Pick up some Burnt Sienna on a no. 24 badger flat and stroke in the dirt pathway that leads down to the shore, keeping this color darker along the left side in the foreground. Allow much of the orange undercoat to show through in a few places to indicate dappled areas of sunlight and shade on the path.

Step 12: Begin Foreground Grasses

Using a no. 10 stiff bristle flat, pick up medium green mix and roughly block in the foreground grassy areas, avoiding the two large trees on either side. Add a touch or two of Sap Green to the medium green for variety of color. Where the grass meets the pathway, let the medium green drift across the path, but don't totally cover the Burnt Sienna color. Allow little hints of the orange undercoat to show through for a little glow and more texture. As the grass approaches the near foreground on either side of the path, pick up dark green on your dirty brush and use the stiff bristles of the brush to texture the grass.

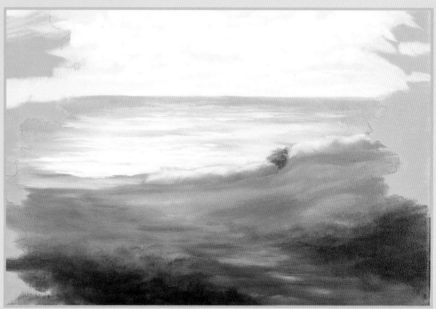

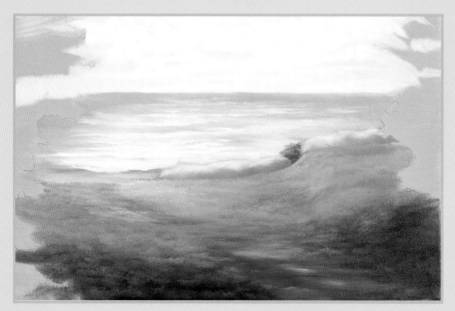

Step 13: Add Highlights and Texture

Brush-mix Naples Yellow and warm white mix and use a no. 8 stiff bristle flat to add the lighter yellow grasses down near the shoreline, using light pressure and a slight downward tapping motion of the bristles. For a softer grass texture, you can switch to a no. 24 badger flat and use the same tapping motion to indicate tufts of grass. For a warmer, more sunlit green, pick up some Cadmium Yellow Light and tap in grasses that are being warmed by sunlight. Lighten some of the darker areas in the near foreground with medium green grasses.

Step 14: Begin Large Trees

Use a no. 8 stiff bristle flat and a lean amount of dark green mix to scrub in the darkest base color of the trees on either side of the foreground. As you're scrubbing in this color, allow a few spots of the distant sky color to show through the foliage; don't cover it up completely.

Step 15: Tap On Leaves

Using a no. 6 badger filbert and the dark green mix, detail the edges of the trees with foliage, using the neutral stroke to suggest individual leaves and clusters of foliage that show against the background of ocean and sky. Keep the brush well groomed as you pick up more paint so you're not laying down blobs of color on your canvas.

Step 16: Detail the Trees

Line in the trunks and branches with the no. 1 script liner and a brush-mix of dark green + a tiny touch of Cadmium Red Light. Highlight the foliage on the tree on the left with a brush mix of Naples Yellow + Cadmium Yellow Light. The tree on the right is first highlighted with touches of medium green mix, then with a light apple green mixed from Sap Green + Titanium White. Use the neutral stroke to tap on these highlights. Highlight the trunks with vertical streaks of the peach mix.

Step 17: Finishing Touches

Place stronger peach highlights on the boulders to strengthen their rugged shapes. Pull some weeds and tall grasses below the rocks with a little thinned medium green mix, shaded with a bit of thinned dark green mix. Touch on some tiny flowers in the grass with Cadmium Red Light. Finish by strengthening the white clouds along the horizon line.

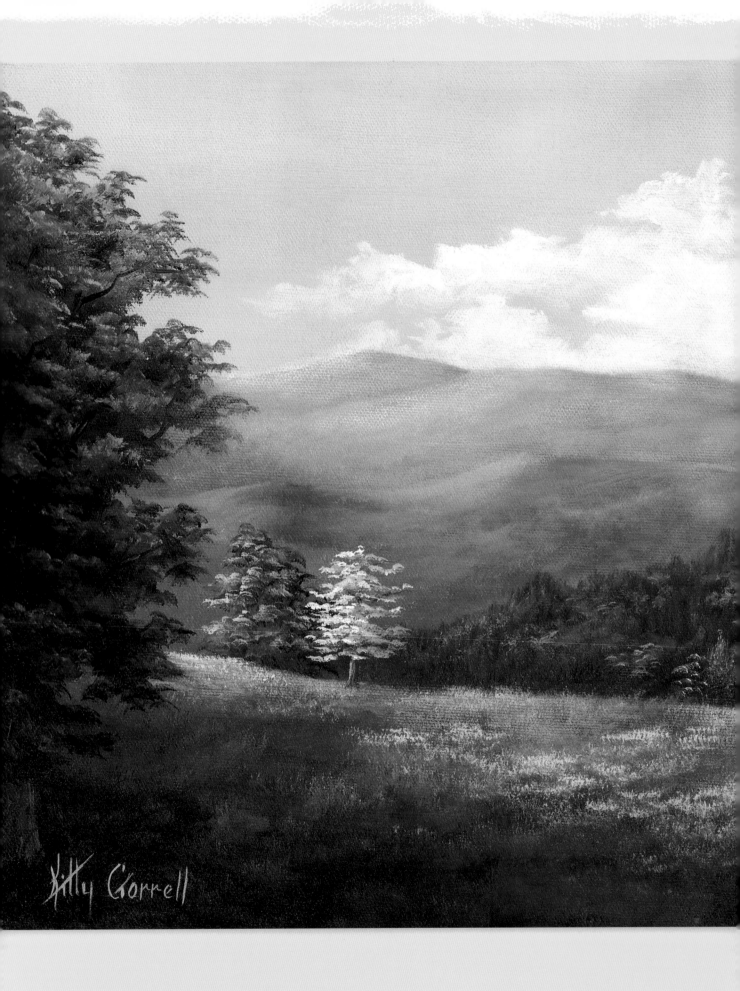

Kitty Gorrell

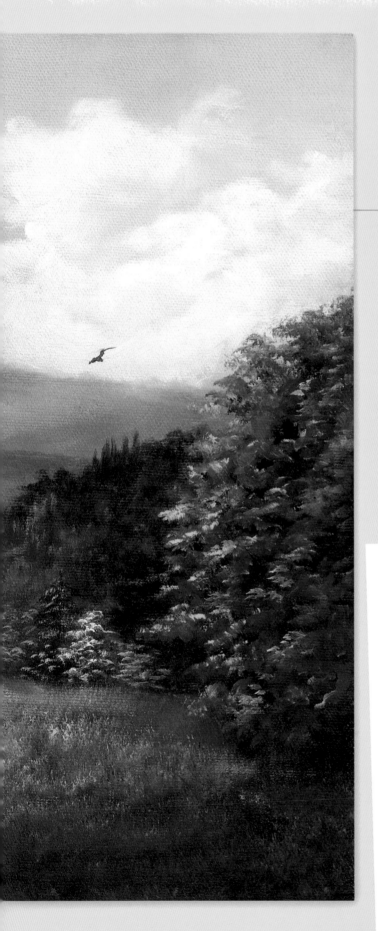

Rolling Hills

8

The rolling hills in the distance achieve their depth through the use of muted, gray-green colors and little detail, while stronger textures, values and colors add interest and detail to the mid-range and foreground. The viewer's eye is led to the center of this painting with the sunny highlights on the trees and grasses plus the placement of the spring dogwood trees. The sizes and values of the trees throughout this painting actually establish a value scale that can be most beneficial in doing any depth-of-field study. The change in values from the distant hills to the foreground can be clearly seen when you look at it as a value scale of grays, which we will do on page 113.

ACRYLIC COLOR FOR UNDERCOATING

DecoArt Americana
"Orange Twist"

OIL COLOR MIXES

 Sky blue mix

Light peach mix Sky blue mix Blue-green mix

Warm white mix Olive green mix

Line Drawing

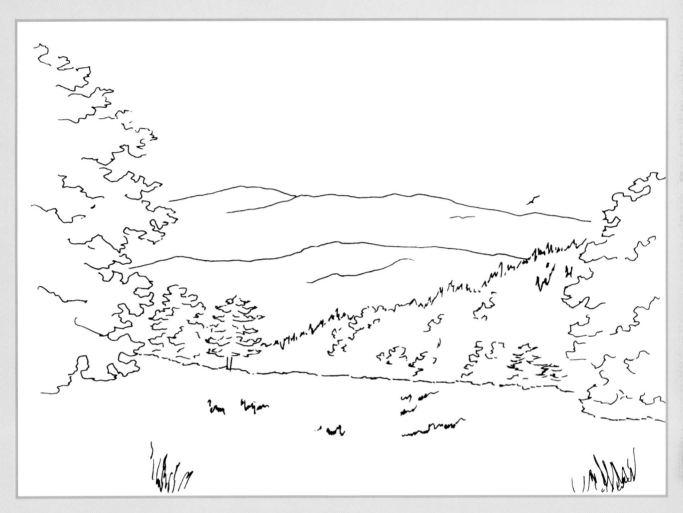

This drawing may be hand-traced or photocopied for personal use only.

Enlarge at 152% to bring it up to full size.

Surface

Stretched canvas, 12 x 16 inches (30 x 41 cm)

Acrylic paint

DecoArt Americana "Orange Twist" or other medium orange acrylic paint

Oil paints

Permalba Professional Oil Colors. Place the following bead-lengths on your palette:

Titanium White: 1½ inches (38mm)

Cadmium Yellow Light: 1/4 inch (6mm)

Naples Yellow: 1/8 inch (3mm)

Perinone Orange: 1/8 inch (3mm)

Cadmium Red Light: 1/16 inch (1.6mm)

Sap Green: 1/2 inch (13mm)

Quinacridone Violet: 1/8 inch (3mm)

Phthalo Blue: 1/4 inch (6mm)

Burnt Sienna: 1/8 inch (3mm)

Burnt Umber: 3/8 inch (10mm)

Ivory Black: 1/4 inch (6mm)

Oil color mixes

Use a palette knife to mix the following colors on your palette:

Light peach mix: 1/4 inch (6mm) Titanium White + touch of Perinone Orange

Sky blue mix: 1/2 inch (13mm) Titanium White + touch of Phthalo Blue + touch of Quinacridone Violet

Blue-green mix: 1/8 inch (3mm) Phthalo Blue + 3/8 inch (10mm) Burnt Umber

Warm white mix: 1/2 inch (13mm) Titanium White + touch of Naples Yellow

Olive green mix: 3/8 inch (10mm) Sap Green + 1/8 inch (3mm) Ivory Black

Brushes

2-inch (51mm) foam, 2-inch (51mm) soft bristle craft brush, nos. 8 and 10 stiff bristle flats, nos. 6 and 8 badger filberts, nos. 12 and 24 badger flats, no. 1 script liner, large soft blending mop

Other materials

Clear medium mix, gray graphite paper, tracing paper, paper towels, palette knife

CANVAS PREPARATION

After you have applied an orange acrylic undercoat and transferred the drawing to the canvas, brush a sparing amount (less than 1 tablespoon) of the clear medium mix over the entire canvas using a 2-inch (51mm) soft bristle brush. Work it well into the canvas. Place a paper towel over the canvas and brush gently over the paper towel to pick up any excess medium. Proceed with the oil painting.

Undercoat with Orange Acrylic and Transfer the Drawing

Cover the entire canvas with an even undercoat of orange acrylic paint using a 2-inch (51mm) foam brush. Let dry completely. Trace or photocopy the line drawing, enlarge to the percentage needed, and transfer to the canvas using gray graphite paper. Make sure the lines show up well. Brush with clear medium following the instructions under "Canvas Preparation" above.

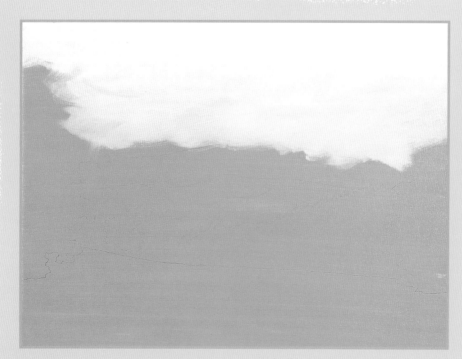

Step 1: Block In Sky Colors

With light peach mix and a no. 10 stiff bristle flat brush, loosely base in the lower two-thirds of the sky area, allowing the color to transition to a very pale value toward the top. With sky blue mix, block in the blue sky area from the top of the canvas downward, softly blending with the peach where the two colors meet.

Step 2: Block in Clouds

With a no. 12 badger flat, loosely block in the cloud shapes with Titanium White. Let many areas of the peach and blue sky colors peek through.

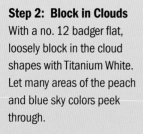

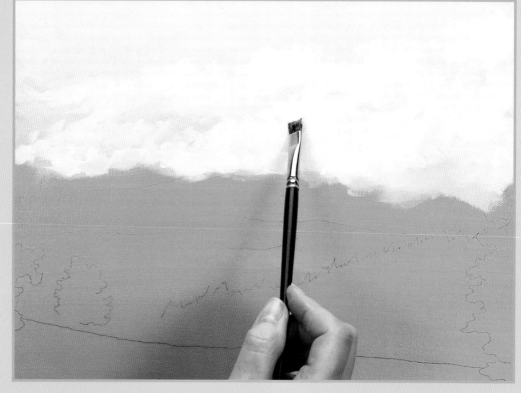

Step 3: Soften and Blend

Soften and blend the sky colors and clouds with a large, soft mop brush. Don't overblend—these clouds still have some distinctive edges.

Step 4: Shade Clouds

Shade and shadow the undersides of some of the clouds with the sky blue mix. Soften again with the mop brush. Keep this shading subtle; you don't want them to become storm clouds.

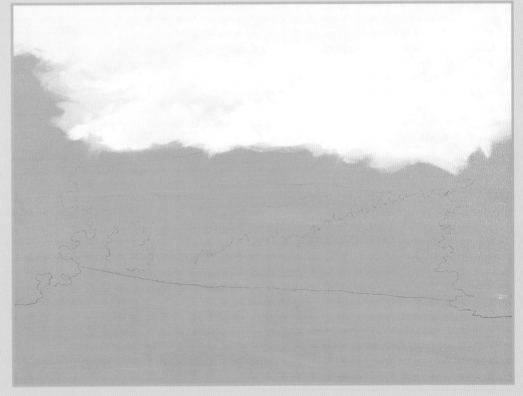

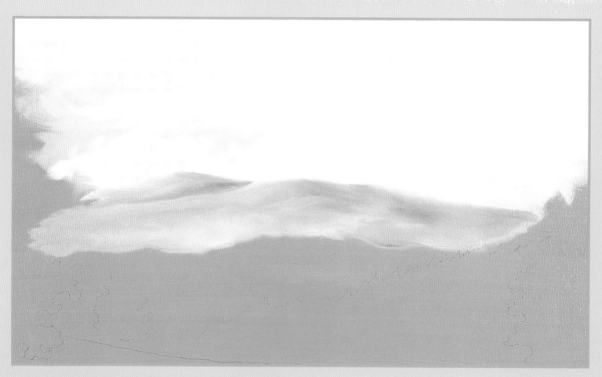

Step 5: Lay In the Distant Hills

Make a brush-mix of the sky blue mix plus a small amount of the blue-green mix to make a grayed green. Lay in the form and shape of the most distant hills using a no. 24 badger flat. Begin laying this color in the valleys and progress upward, letting the paint run out so the upper ridges are paler and less distinct than the slopes and valleys. Indicate shadowed areas and valleys with a little bit more of this grayed green. Highlight the lightest areas and add thin hazy clouds and fog coming up out of the valley using very lean amounts of the warm white mix. Soften the highest ridgeline by mopping very gently, starting at the ridge and pulling the mop brush downward into the mountain area, not up into the sky.

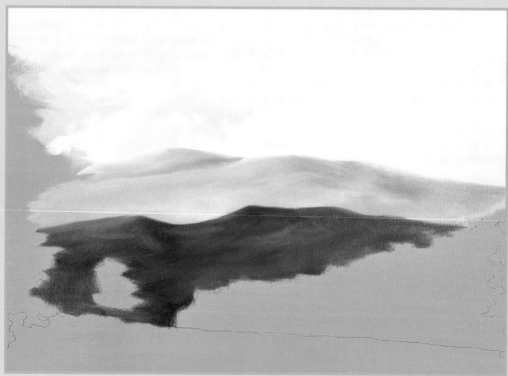

Step 6: Add Mid-ground Hills

Make an earthy green color with a brush-mix of the olive green mix and the blue-green mix, plus a touch of Naples Yellow. Lay in the shapes of the hills in the mid-ground. Allow this color to be darker in the valley and on the shadowed sides of the hills, and lighter in value on the sunlit sides. Avoid painting over the trees on either side in the foreground.

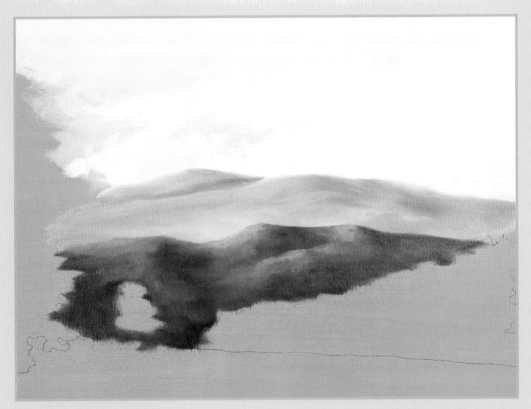

Step 7: Highlight the Hills
Highlight the lighter areas and sunlit slopes of these hills with a light green brush-mix of Titanium White + a touch of Sap Green. Use a no. 12 badger flat and blend slightly as you work. Keep in mind that the direction of the sunlight is from the upper left. Indicate grassy textures on these hills by tapping on the lightest lights of Cadmium Yellow Light and warm white mix, using the chisel edge of the brush and very light pressure.

Step 8: Begin Forested Hillside
Base in the dense forest at right, using the dark blue-green mix and a no. 8 stiff bristle flat that you hold so the chisel edge is vertical. Tap this color on repeatedly, don't stroke. This gives the look of tall dark evergreens along the ridgeline.

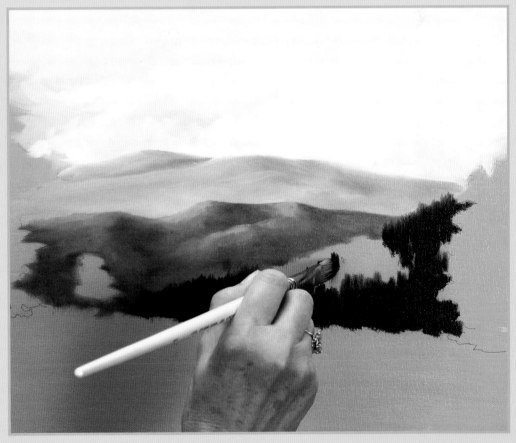

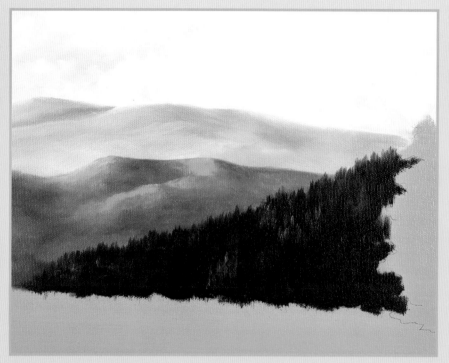

Step 9: Tap In Lighter Trees

Switch to a no. 12 badger flat and detail the ridgeline with this smaller brush to indicate individual treetops here and there. Begin adding lighter-color trees on the forested slope using Naples Yellow in some places, the light green brush-mix from step 7, and just a hint of Cadmium Yellow Light. Hold the brush vertically just as you did in step 8 to indicate tall trees and tap the brush gently to the canvas.

Step 10: Add Deciduous Trees Among the Evergreens

To indicate deciduous trees on this slope, switch to a no. 6 badger filbert and use the same lighter colors used in step 9. But this time, hold your brush so the bristles are horizontal, and tap these colors on very gently to indicate rounded tree shapes. Do not overdo these colors and textures— they need to remain subdued so the forest stays in the background.

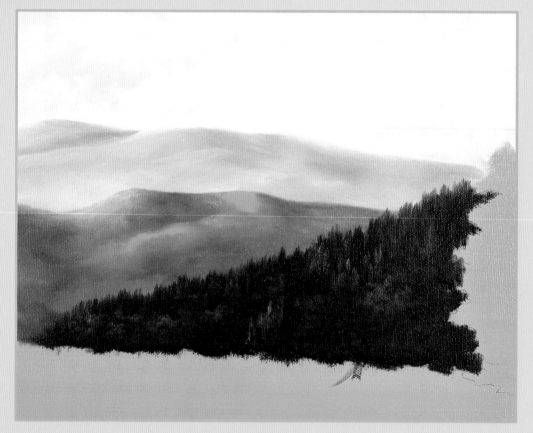

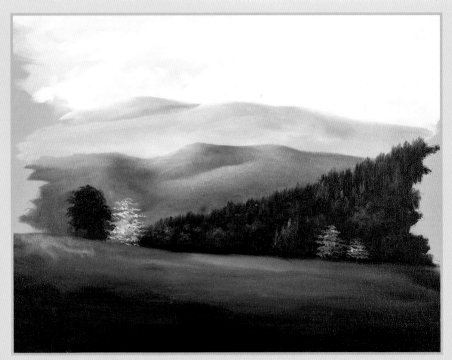

Step 11: Begin Mid-ground Field and Trees

Base in the foreground of the field starting at the bottom edge of the canvas and working upward, using brush-mixes of olive green and blue-green. As you progress into the lighter areas of the field, add touches of a light green mix of Titanium White + a little Sap Green. Stroke these colors horizontally using a large, stiff bristle flat. The deciduous tree at the left of the grassy field is tapped in with a brush-mix of blue-green + a touch of Sap Green on a no. 6 badger filbert. Begin the white dogwood trees by tapping on a base color of sky blue darkened with just a touch of Phthalo Blue and Quinacridone Violet. Let this color tack up while you work on the field grasses.

Step 12: Highlight Field Grasses

Highlight the field grasses with Cadmium Yellow Light, most of which will turn to a soft light green as you tap over the green base colors you applied in the previous step. Use a large stiff bristle flat to tap on the grass textures. Don't overblend—let the textures remain rough and uneven.

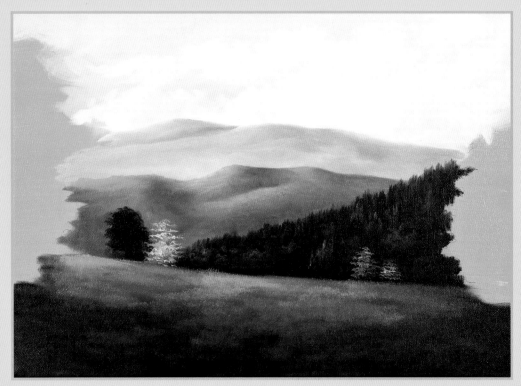

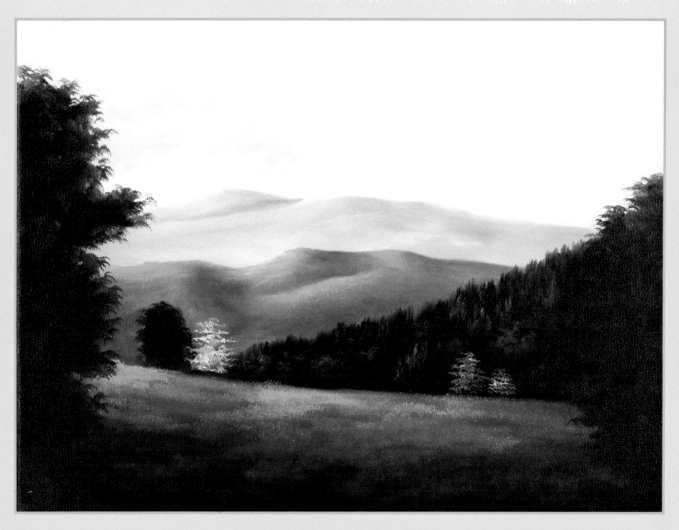

Step 13: Begin Foreground Trees

Begin work on the two largest trees in the near foreground. Block them in with
a large stiff bristle flat and tapping motions, using a lean amount of the olive
green mix for the tree on the right, and olive green and blue-green for the tree
on the left. Switch to a no. 8 filbert and add detail to the silhouette of the trees
by tapping on branches and foliage that are visible against the lighter colors of
the sky and background hills.

Landscape Lesson #8: Using a Gray Scale to See Values and Depth of Field

The rolling hills in the distance achieve their depth through the use of muted gray-green colors and little detail, while stronger textures, values and colors bring to the front the mid-range and foreground. The sizes and values of the trees and foliage throughout this painting actually establish a value scale that can be most beneficial in doing any depth-of-field study.

The change in values from the distant hills to the foreground can be clearly seen if you look at it as a value scale of grays. The "7-Step Value Scale" shown at bottom is a gray scale that runs from the lightest value (white) to the darkest value (black) with several values of gray in between. The numbers on the value study below correspond to the shades of gray on the 7-step scale. Compare the value study below to the photo of our painting-in-progress at left. When color is removed, the values stand out clearly.

To assist you in seeing the relative values of a landscape, make a black and white copy of your reference photo and study the scene first in just the gray values. You may also paint your own value study from your photograph. This will help you see the relative value of the colors in your final painting, especially the greens, blues and browns that dominate most landscapes.

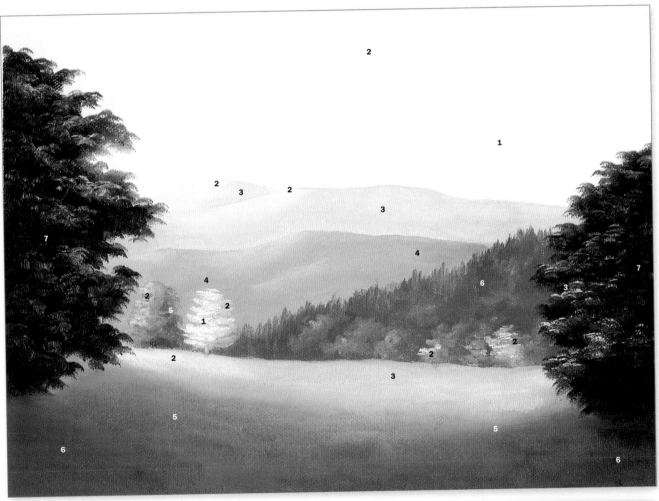

7-Step Value Scale

1 2 3 4 5 6 7

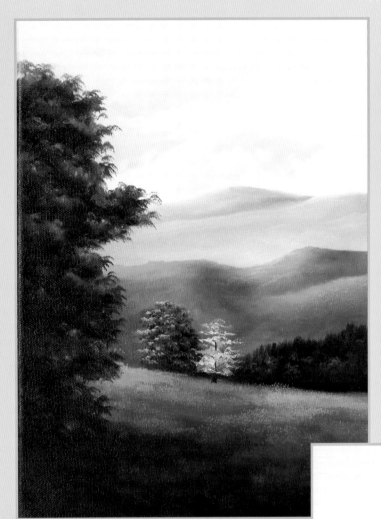

Step 14: Shape and Highlight Trees on Left

Shape and highlight the foreground tree on the left side with neutral strokes of Naples Yellow. The small deciduous tree in the mid-ground is highlighted with neutral strokes of Cadmium Yellow Light on the left, sunlit side, and with Naples Yellow on the right, shaded side.

Step 15: Highlight Foreground Tree on Right

Touch on highlights of Cadmium Yellow Light on the tree on the right using a no. 6 filbert and the neutral stroke. Keep these highlights where the outer tips of the branches are catching the sunlight.

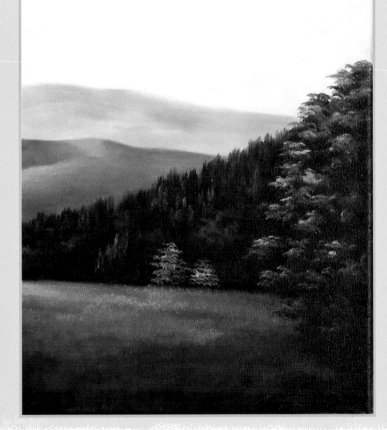

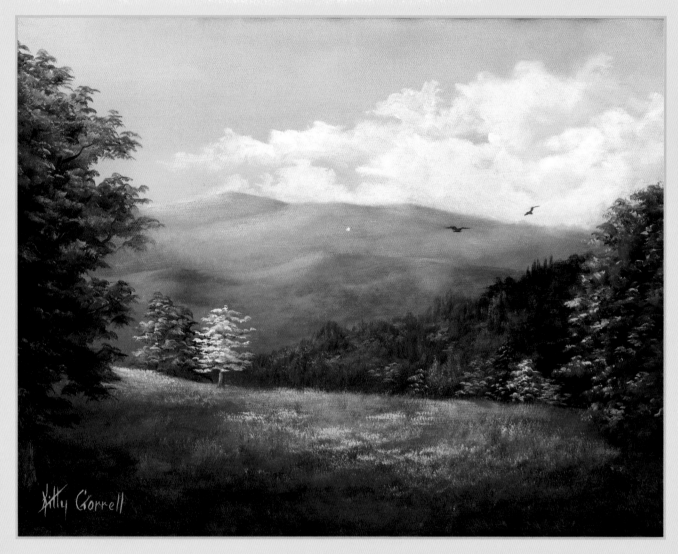

Step 16: Final Details

With straight Titanium White on a small filbert, highlight the white dogwood trees at the left and right sides of the grassy field. Do not entirely cover the blue base color you applied to these trees in step 11. Add the redbud trees in front of the dark forested hillside with touches of a dark pink brush-mix of Cadmium Red + Quinacridone Violet. Highlight with a strong pink made from Titanium White and a touch of the dark pink mix. Tuck in some small green trees among the dogwoods and redbuds for more interest. Brighten and texturize the sunlit areas of the field with taps of Cadmium Yellow Light. Strengthen the cloud shapes with Titanium White and redefine some of the outer edges. If you wish, add a few subtle touches of reflected sky color to the most distant hills. Finish with a couple of soaring birds using a no. 1 script liner and Burnt Sienna shaded with Burnt Umber.

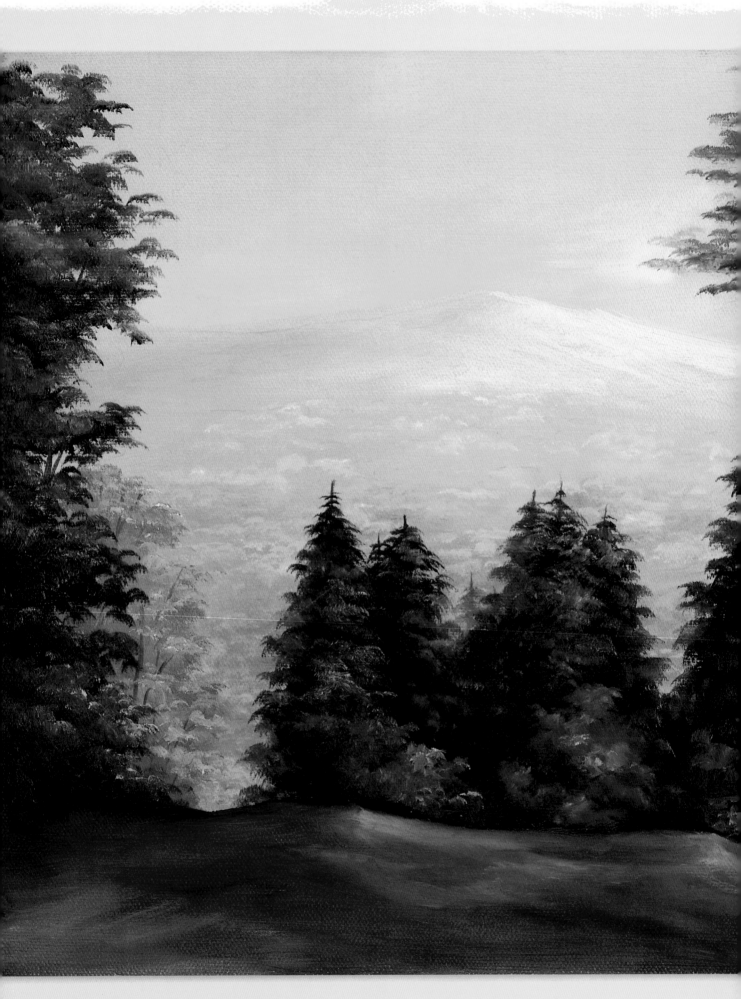

On a Clear Day

9

In this painting of autumn colors both near and far, the illusion of great distance across the valley and to the mountain range in the background is achieved in several ways. First, the strong colors and sharp details of the closest trees and land bring them strongly into the foreground. Second, the value of the distant mountain range is close to the value of the sky, thereby setting it into the distant background. Third, the fall colors of the trees in the valley are obscured by atmospheric haze and therefore are decreased in value and intensity regardless of color. They are simply slight touches of color to indicate the tree tops as seen going off into the distance. The more distant they become, the smaller and more muted the touches of color.

ACRYLIC COLOR FOR UNDERCOATING

DecoArt Americana
"Orange Twist"

OIL COLOR MIXES

Peach mix Sky blue mix Blue haze mix Light blue-green mix

Dark base green mix Rust red mix Autumn green mix

Line Drawing

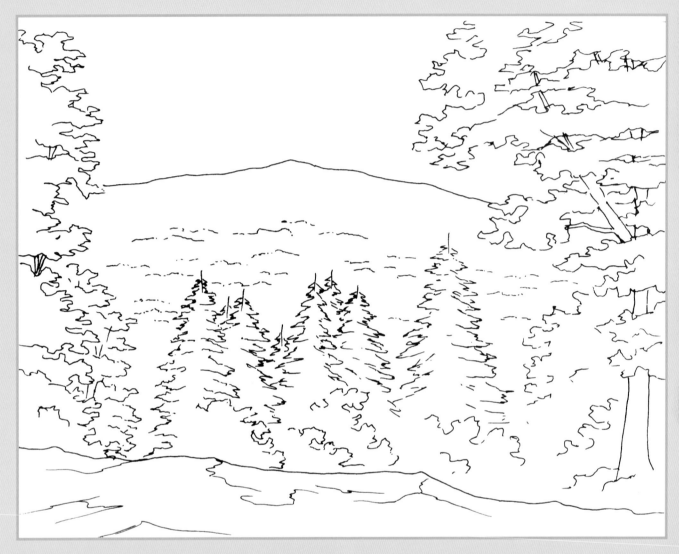

This drawing may be hand-traced or photocopied for personal use only.

Enlarge at 141% to bring it up to full size.

Surface
Stretched canvas, 11 x 14 inches
(28 x 36 cm)

Acrylic paint
DecoArt Americana "Orange Twist" or other medium orange acrylic paint

Oil paints
Permalba Professional Oil Colors.
Place the following bead-lengths on your palette:

Titanium White: 1½ inches (38mm)

Cadmium Yellow Medium: 1/8 inch (3mm)

Naples Yellow: 1/8 inch (3mm)

Perinone Orange: 1/8 inch (3mm)

Sap Green: 1/2 inch (13mm)

Quinacridone Violet: 1/8 inch (3mm)

Phthalo Blue: 1/4 inch (6mm)

Raw Sienna: 1/8 inch (3mm)

Burnt Sienna: 1/2 inch (13mm)

Ivory Black: 1/3 inch (8.5mm)

Oil color mixes
Use a palette knife to mix the following colors on your palette:

Peach mix: 1/4 inch (6mm) Titanium White + touch of Perinone Orange

Sky blue mix: 1/2 inch (13mm) Titanium White + touch of Phthalo Blue + touch of Quinacridone Violet

Blue haze mix: 1/4 inch (6mm) sky blue mix + touch of Phthalo Blue + touch of Quinacridone Violet

Autumn green mix: 3/8 inch (10mm) Burnt Sienna + 1/8 inch (3mm) Phthalo Blue

Light blue-green mix: 1/4 inch (6mm) sky blue mix + touch of autumn green mix + touch of Titanium White

Dark base green mix: 1/2 inch (13mm) Sap Green + 1/3 inch (8.5mm) Ivory Black + 1/4 inch (6mm) Phthalo Blue

Rust red mix: 1/8 inch (3mm) Burnt Sienna + touch of Quinacridone Violet

Brushes
2-inch (51mm) foam, nos. 8 and 10 stiff bristle flats, nos. 6 and 8 badger filberts, nos. 6 and 12 badger flats, no. 1 script liner, large soft blending mop

Other materials
Liquiglaze medium, small plastic cup, gray graphite paper, tracing paper, paper towels, palette knife

Undercoat with Orange Acrylic and Transfer the Drawing
Cover the entire canvas with an even undercoat of orange acrylic paint using a 2-inch (51mm) foam brush. Let dry completely. Trace or photocopy the line drawing, enlarge to the percentage needed, and transfer to the canvas using gray graphite paper. Make sure the lines show up well. Pour a small amount of Liquiglaze medium into a small plastic cup and keep near your palette. You'll be adding touches of this medium to your paint as you work to speed drying time, making it easier to layer the fall colors.

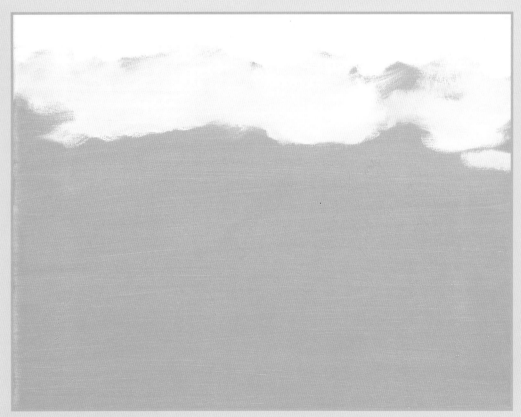

Step 1: Block In Sky Colors

With a no. 10 stiff bristle flat brush, work the peach mix into the lower sky area. Wipe out the brush on a paper towel and work the sky blue mix into the upper sky area all the way to the top of the canvas.

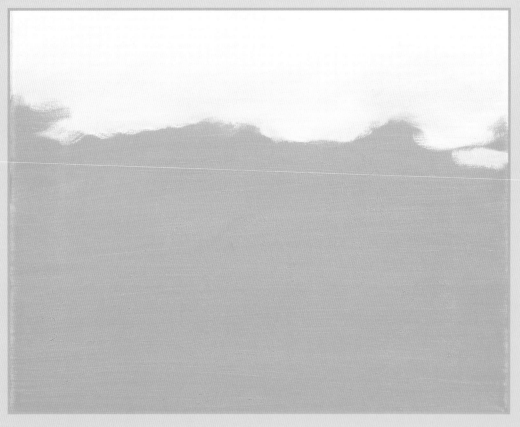

Step 2: Blend Sky Colors

Using a large soft mop brush, blend these two sky colors where they meet, and work the colors to give a soft, hazy look to the sky.

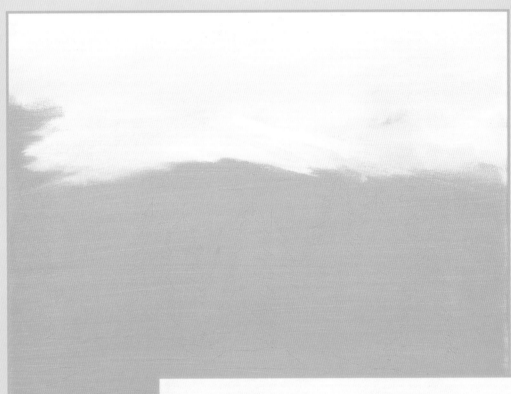

Step 3: Base in Distant Mountain

Base in the form of the far distant mountain using the blue haze mix, a blue that is just a couple of values deeper than the sky blue mix. Highlight the right slope of the mountain with a brush-mix of peach + Titanium White. Allow some hints of the orange undercoat to peep through.

Step 4: Begin Trees in Valley

Pick up a tiny touch of Liquiglaze medium on the corner of your no. 10 stiff bristle flat, then pick up the light blue-green mix. Stroke across the lay of the land in the valley beneath the distant mountain. Allow this green to become a little heavier as you work the color in between the foreground evergreens.

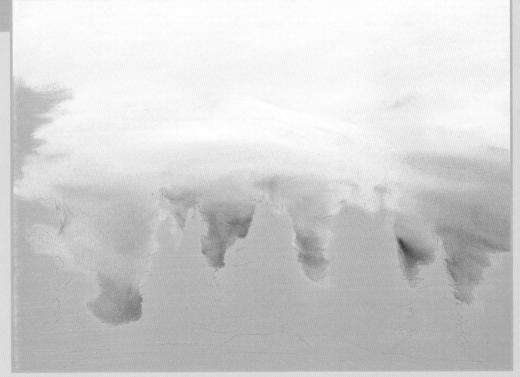

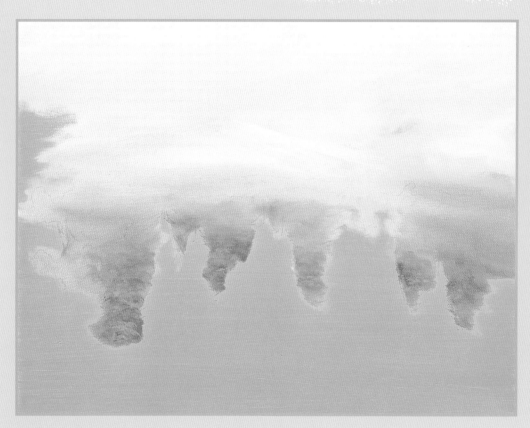

Step 5: Tap on Tops of Distant Trees

Switch to a no. 8 badger filbert, pick up a touch of Liquiglaze medium and a brush-mix of Naples Yellow + the dark base green mix, and begin lightly tapping in the textures of the tops of distant trees that can be seen in between the foreground evergreens. Pick up Cadmium Yellow Medium for some lighter yellow colors in these distant trees.

Step 6: Add More Fall Colors

With your no. 8 filbert, continue lightly tapping in fall colors in the treetops in the valley, using a pale orange mix (peach mix + a touch of Perinone Orange), a light gold mix (Titanium White + Naples Yellow), and a medium green mix (Naples Yellow + dark base green mix). Keep the pressure on your brush very light, barely touching the canvas with the tips of the bristles. Knock down the textures with a soft mop brush. You may need to repeat this step after the paint has dried somewhat and you can judge the strength of your colors.

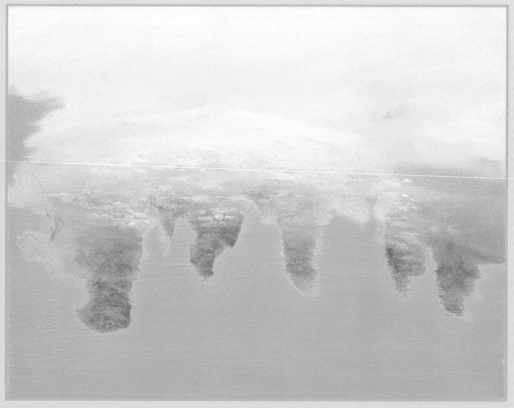

Landscape Lesson #9: Paint What You See, Not What You Know

In a landscape that includes bright colors such as this one, the illusion of great distance across the valley and to the mountain range in the background is achieved in large part by decreasing the value and intensity of the colors as you move to the background. Resist the temptation to paint these autumn colors stronger! You know that, up close, these background trees are as bright and colorful as the foreground trees, but if you paint them that way (as shown in the study below) the whole painting will look wrong. The illusion of great distance is destroyed because the colors and values are too strong. The mountain moves up into the mid-ground and the valley disappears. To keep the distant mountain in the distance and the valley in the mid-ground, remember that the intervening atmospheric haze always decreases color intensities, lessens contrast and makes values lighter, as shown in the painting at bottom. In other words, paint what you see, not what you know.

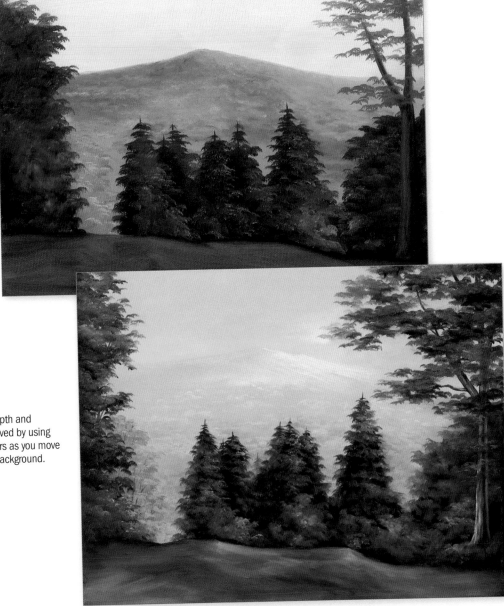

Wrong
Painting looks flat because all the fall colors are the same intensity.

Right
The illusion of depth and distance is achieved by using less intense colors as you move further into the background.

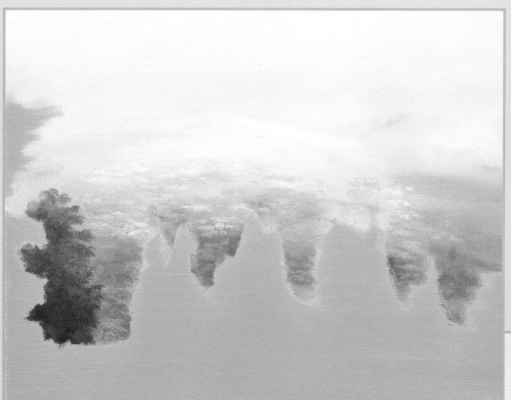

Step 7: Begin Rust Colored Tree

Make a rust red mix using a lean amount of Burnt Sienna + Quinacridone Violet. Base in the rust colored tree in the left foreground with a no. 12 badger flat. Clean up the edges and the silhouette with a no. 6 filbert. Add some clusters of orange foliage to the tree with Perinone Orange on the no. 6 filbert.

Step 8: Highlight Rust Colored Tree

Place light orange highlights with the peach mix + a little more Perinone Orange using the neutral stroke and a no. 6 filbert. Tap these highlights on the tops and outside branches where the sunlight hits them.

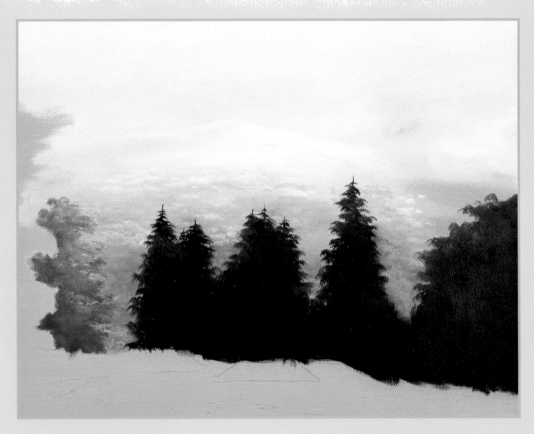

Step 9: Begin Evergreens
Using the neutral stroke, block in the central evergreen trees and the large rounded bush at the far right with the autumn green mix and a no. 8 filbert. Since these are foreground trees, shape and detail the outer ends of the branches that are silhouetted against the distant valley. This detailing helps bring these trees closer to the foreground.

Step 10: Highlight Evergreens
Highlight the trees primarily on the right-hand side with Naples Yellow and a no. 6 filbert. This will give them more shape and separate them from one another. For the brighter highlights use Naples Yellow + Cadmium Yellow Medium. The bush to the far right is highlighted with Naples Yellow to create a dull green. Save the brighter highlights for the bushes in front of the evergreens we'll be painting in the next step.

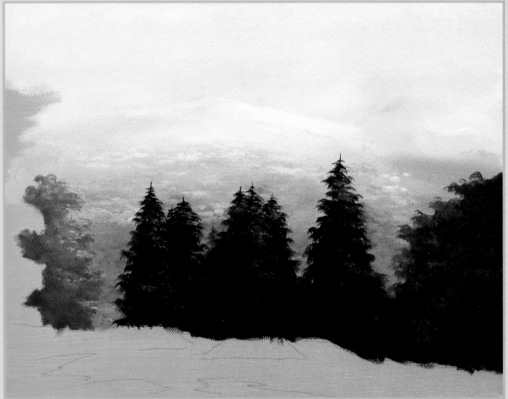

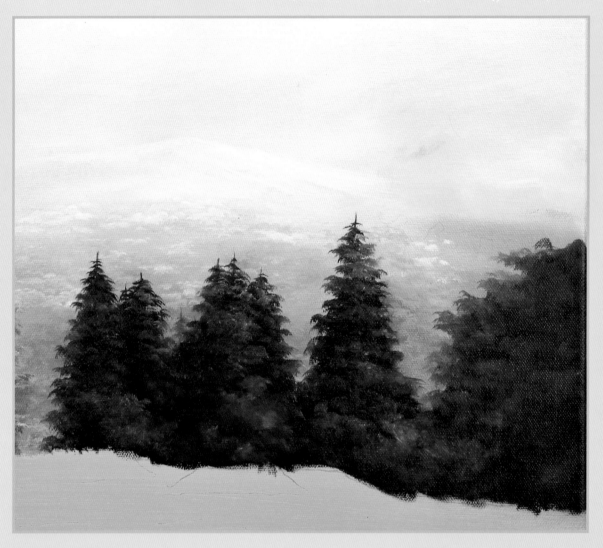

Step 11: Highlight Foreground Bushes

The bushes in front of the evergreens are highlighted with a light green value made from Titanium White + Sap Green using neutral strokes and the no. 6 filbert. Final highlight touches are tapped on with Cadmium Yellow Medium. Keep these sparse for now; we'll come back later to adjust the highlights if needed.

Step 12: Begin Large Tree at Left

Using the neutral stroke, base in the large tree on the left with the autumn green mix and the no. 8 filbert. Leave some open areas throughout the tree so the background shows through and it isn't totally solid. This tree overlaps the rust colored tree because it is in the foreground closest to the viewer. Therefore the foliage should be more detailed, sharper-edged and more distinct than the foliage of the rust colored tree behind it.

Step 13: Highlight Foreground Tree

Highlight the large foreground tree sparingly with Naples Yellow to give the tree a little life. The Naples Yellow will become a soft highlight color when placed on the still-wet autumn green mix. Now that the large tree is in place, go back to the rust colored tree and place some interior branches using the no. 1 script liner and Burnt Umber thinned with medium.

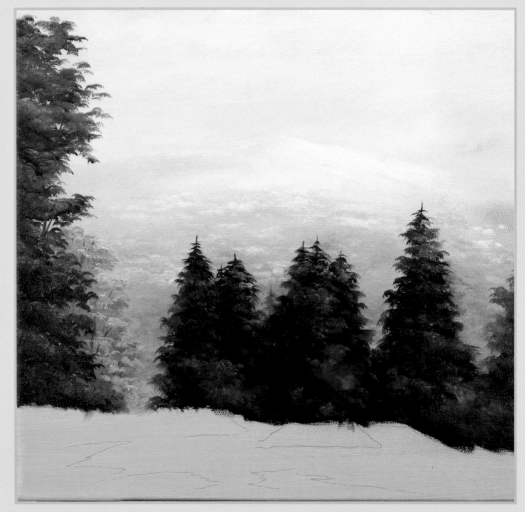

Step 14: Begin Fall Tree at Right

Base in the trunk and branches of the large tree on the right with a no. 6 badger flat and a brush-mix of Ivory Black + Burnt Umber + medium. Do as much as you can with the no. 6 flat and then switch to the no. 1 script liner for the smaller branches and twigs. Create a cool highlight on the right-hand side of this tree with the sky blue mix and the no. 6 flat. This separates the trunk from the background bush. Highlight the left side of the trunk with touches of the peach mix.

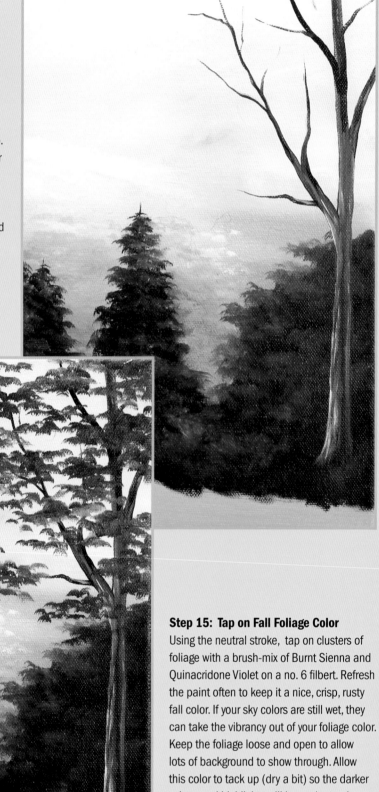

Step 15: Tap on Fall Foliage Color

Using the neutral stroke, tap on clusters of foliage with a brush-mix of Burnt Sienna and Quinacridone Violet on a no. 6 filbert. Refresh the paint often to keep it a nice, crisp, rusty fall color. If your sky colors are still wet, they can take the vibrancy out of your foliage color. Keep the foliage loose and open to allow lots of background to show through. Allow this color to tack up (dry a bit) so the darker values and highlights will be easier to place.

Step 16: Add Some Darker Leaves

Add darker, more shadowed foliage with dark base green mix and a clean no. 6 filbert. Use the neutral stroke again and keep the foliage open and airy.

Step 17: Highlight Fall Foliage

Soften the textures of the foliage with a soft mop brush, working inward from the outer edges of the branches. Highlight sparingly with pure Perinone Orange on a no. 6 filbert to create some high-impact foliage. Wipe out your brush each time you go back for fresh paint so the orange does not become contaminated. Place the orange where the tree would naturally catch the most light. If the orange goes into a darker area it needs to be toned down by working the color a bit into the background.

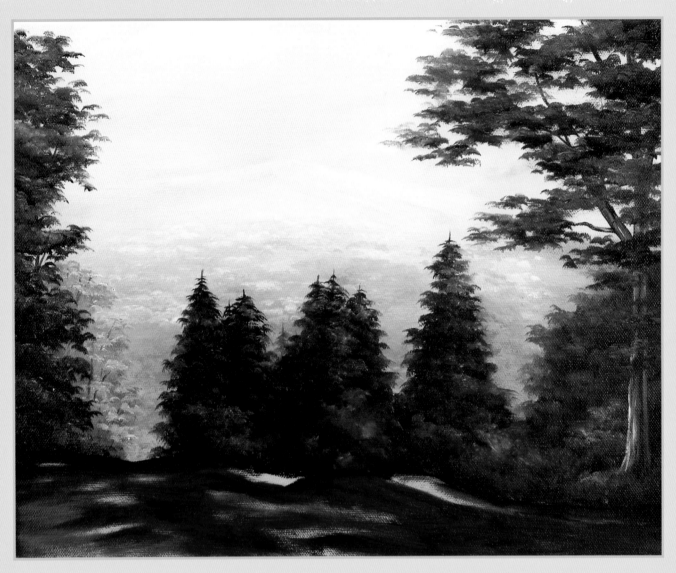

Step 18: Foreground Land Area

Using some Burnt Umber, Quinacridone Violet and medium on a no. 8 stiff bristle flat brush, lay in the darkest values of the foreground land area with quick painterly strokes. Allow hints of the orange canvas to show through. This area is primarily bare earth and rock, with very little detail.

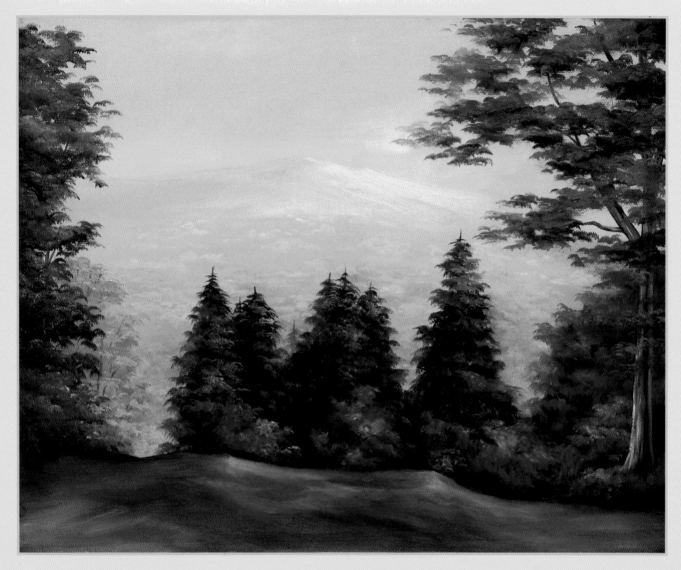

Step 19: Final Details

With the no. 8 stiff bristle flat, add a touch of Burnt Sienna into the lightest foreground areas to cover the orange canvas still showing through. Then highlight with light orange (peach mix + Perinone Orange). Touch it in and smooth out the textures. Any cool highlights are touches of sky blue mix. If needed, go back in with the base color (Burnt Umber + Quinacridone Violet) and re-establish darks or create interesting shadow areas. The deepest shadow areas can even have a hint of black. Build on the highlights with light orange and a no. 6 filbert. Use a deliberate stroke, soften the edges, and leave it. With Burnt Umber + Ivory Black, deepen the edge shadows where the bare earth meets the low foreground shrubs. Reinforce the highlights on the shrubs and on the central evergreens with a no. 6 filbert and Cadmium Yellow Medium. Strengthen the blue and peach sky colors to help define the ridgeline of the distant mountain. Highlight the right side of the mountain slope with a lean amount of Titanium White, and add a bit more color to the treetops in the valley using the same colors from steps 5 and 6.

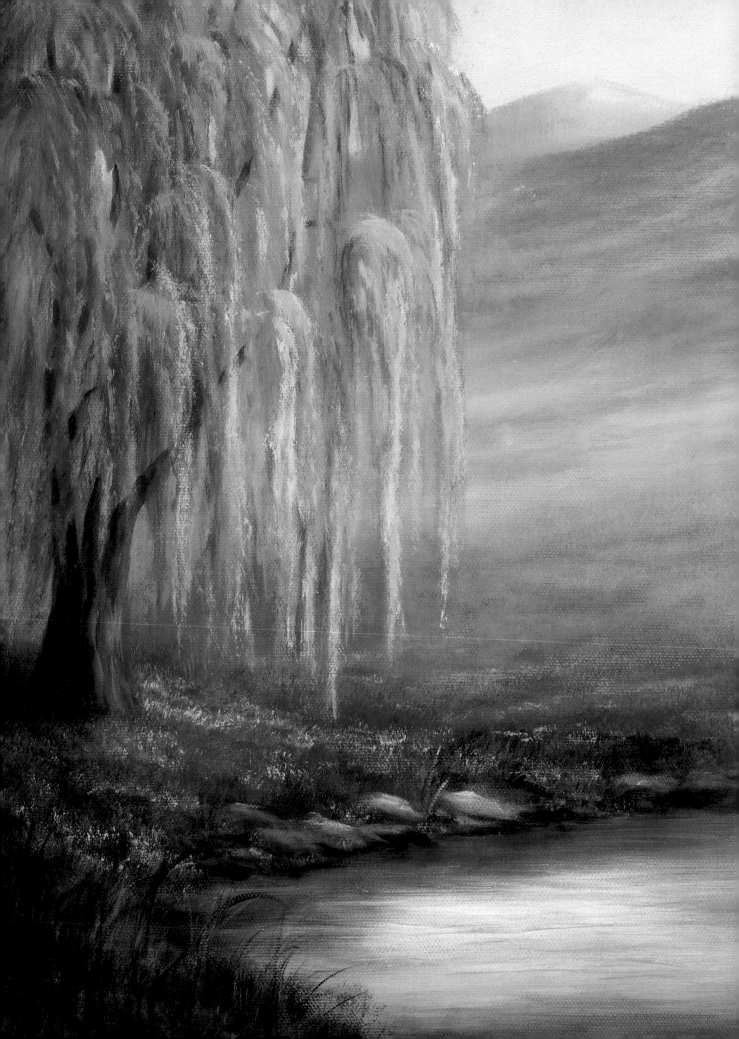

Willow
Pool

For our final lesson, let's look at what can be termed a more "intimate" landscape. This is not a vast scenic landscape on a grand scale. Instead, a delicate and airy willow tree commands the attention in this painting. Most of the detail and interest is in the foreground. Depth is achieved by allowing the viewer to see through and around the tree to the background meadows and on to the distant hills beyond. Sunlight and shadows create interest in these mid-range and background areas without giving too much detail or texture. The branches of the willow tree give a feeling of openness that allows for peeks of the background throughout. The branches flow gently downward with only subtle color variations for sunlight and shadows. The sizes, details and colors of the rocks, grasses and flowers at the base of the tree, plus the reflections in the pool of water, bring this area of the painting into the sharp focus of the foreground.

ACRYLIC COLORS

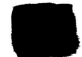

DecoArt Americana "Orange Twist"

Prima Black Gesso

OIL COLOR MIXES

Peach mix

Light blue mix

Olive green mix

Blue-green mix

Shadow blue mix

Light green mix

Line Drawing

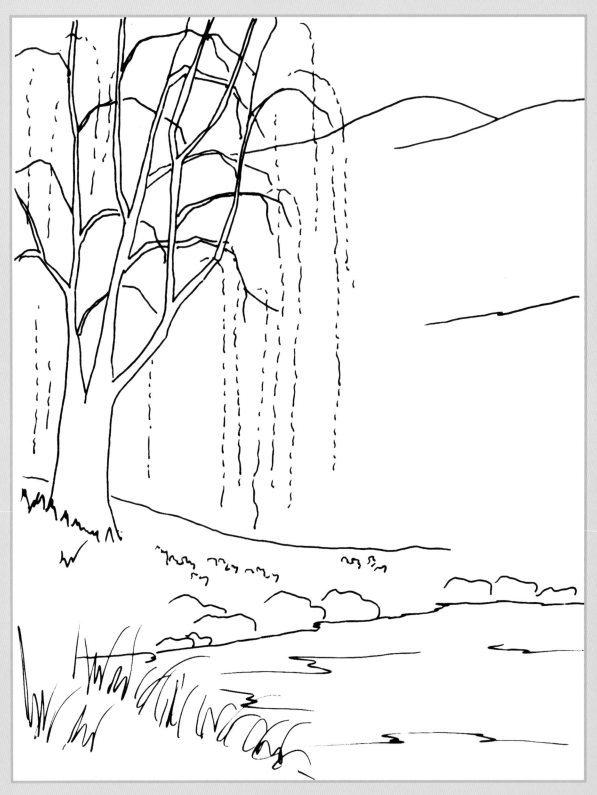

This drawing may be hand-traced or photocopied for personal use only. Enlarge at 133% to bring it up to full size.

Surface
Stretched canvas, 14 x 11 inches (36 x 28 cm)

Acrylic paints
DecoArt Americana "Orange Twist" or other medium orange acrylic paint. Prima Black Gesso to base in darkest values.

Oil paints
Permalba Professional Oil Colors. Place the following bead-lengths on your palette:

Titanium White: 1½ inches (38mm)

Cadmium Yellow Light: 1/16 inch (1.6mm)

Naples Yellow: 1/4 inch (6mm)

Perinone Orange: 1/16 inch (1.6mm)

Sap Green: 1/2 inch (13mm)

Quinacridone Violet: 3/8 inch (10mm)

Phthalo Blue: 1/4 inch (6mm)

Burnt Umber: 3/8 inch (10mm)

Ivory Black: 1/2 inch (13mm)

Oil color mixes
Use a palette knife to mix the following colors on your palette:

Peach mix: 1/2 inch (13mm) Titanium White + touch of Perinone Orange

Light blue mix: 1/2 inch (13mm) Titanium White + touch of Phthalo Blue + touch of Quinacridone Violet

Olive green mix: 3/8 inch (10mm) Sap Green + 1/8 inch (3mm) Ivory Black

Blue-green mix: 1/8 inch (3mm) Phthalo Blue + 3/8 inch (10mm) Burnt Umber

Shadow blue mix: 1/16 inch (1.6mm) Phthalo Blue + 1/8 inch (3mm) Ivory Black + 1/4 inch (6mm) Quinacridone Violet. Add touches of this mix to Titanium White for medium to dark values of blue throughout this painting.

Light green mix: 1/4 inch (6mm) Titanium White + 1/16 inch (1.6mm) Sap Green

Brushes
2-inch (51mm) foam brush, 1/4 inch (6mm) synthetic bristle flat, 2-inch (51mm) soft bristle brush, no. 10 stiff bristle flat, no. 6 badger filbert, nos. 10, 12 and 24 badger flats, large soft mop brush, no. 1 script liner, no. 3 fan

Other materials
Clear medium, gray graphite paper, tracing paper, paper towels, palette knife

Undercoat with Orange Acrylic, Transfer the Drawing and Base in Darkest Values
Cover the entire canvas with an even undercoat of orange acrylic paint using a 2-inch (51mm) foam brush. Let dry completely. Trace or photocopy the line drawing, enlarge to the percentage needed, and transfer to the canvas using gray graphite paper. Make sure the lines show up well. Using black acrylic gesso and a 1/4 inch (6mm) synthetic bristle flat, base in the tree trunk and branches with smooth, flowing strokes, and also the rocks and shadowed edge of the pond. Let dry completely. Brush a sparing amount (less than 1 tablespoon) of clear medium over the entire canvas using a 2-inch (51mm) soft bristle brush. Work it well into the canvas. Place a paper towel over the canvas and brush gently over the paper towel to pick up any excess medium. Proceed with the oil painting.

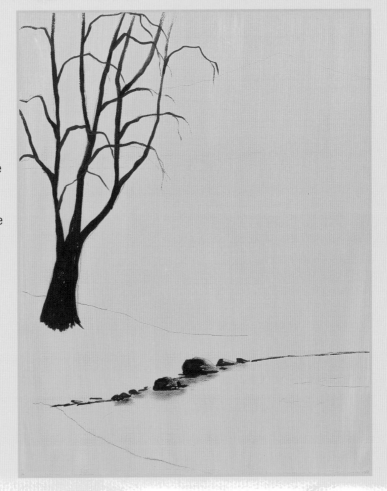

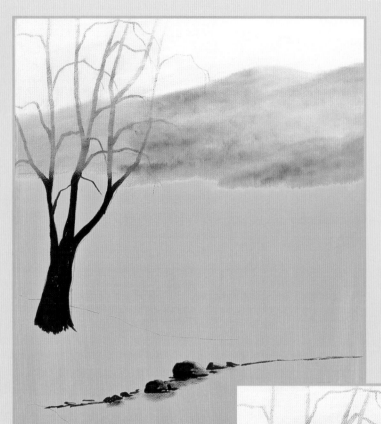

Step 1: Block In Sky and Distant Hills

Pick up peach mix on a no. 10 stiff bristle flat brush and loosely place this color into the lower sky area. Wipe out the brush, pick up the light blue mix and place a band of this color into the upper sky. Let your brush run out of this color as you work toward the lower peach area. Blend these two colors where they meet. Brush-mix light blue and some olive green mix to make a dull mint green color and stroke in the distant hills. Work right over the black tree shapes; we'll come back later and re-establish those. Pick up a little olive green mix on your dirty brush and tap on shaded areas along the slopes.

Step 2: Paint Mid-ground Fields

Continue coming forward with the greens of the mid-ground fields using a brush-mix of Titanium White, olive green mix, and Naples Yellow. Brighten up the greens of the grasses as they come forward closer to the pond by adding a little Sap Green to your brush-mix. Darken the green around the edge of the pond with a little blue-green mix on your dirty brush.

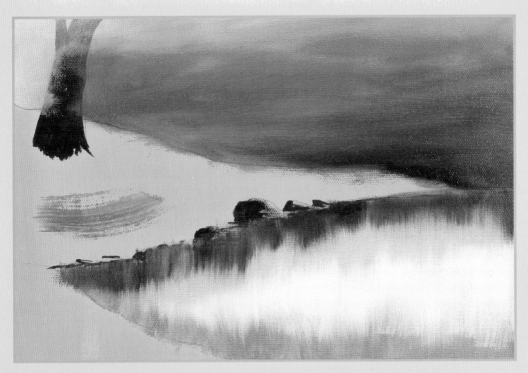

Step 3: Paint Water Reflections

Using the no. 10 stiff bristle flat and only vertical strokes, place light blue mix into the center of the pond for sky reflection color; pull shadow blue mix up from the bottom edge of the pond; pull light green mix over the light blue; and finish with vertical strokes of blue-green mix along the top edge of the pond.

Step 4: Soften and Blur Reflections

Switch to a no. 24 badger flat and, using horizontal motions only, gently blend across the pond to soften and blur the reflected colors. Wipe your brush off on a paper towel after every few strokes so you're not re-depositing paint.

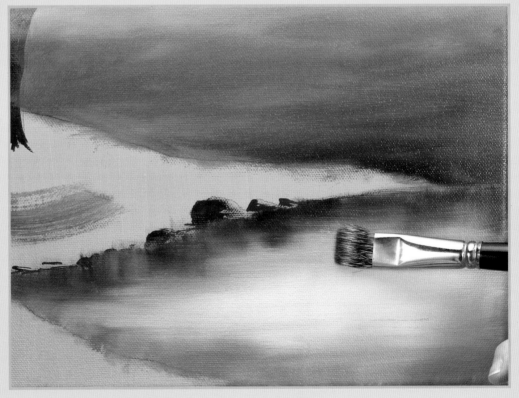

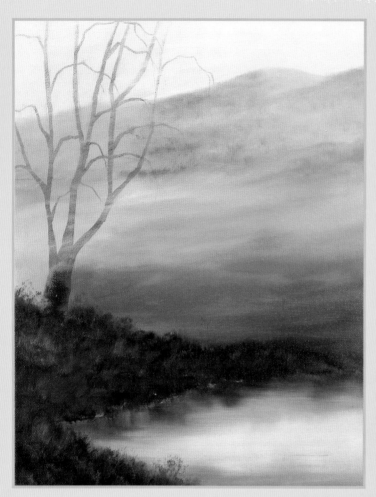

Step 5: Begin Shaded Area Under Tree

Base in the shaded grass areas under the willow tree with a lean amount of blue-green mix. Add touches of light green mix, and a brush-mix of Naples Yellow and Cadmium Yellow Light to get some lighter grass colors. Use a no. 10 stiff bristle flat and upward strokes to get textures and suggestions of grass blades around the edge of the pond.

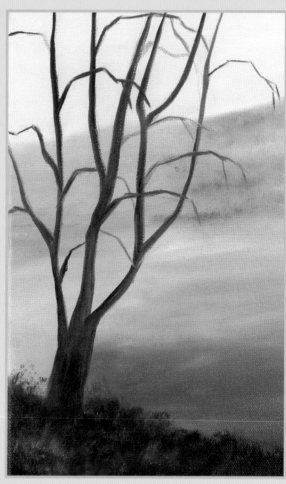

Step 6: Paint Tree Trunk and Branches

With a brush-mix of Burnt Umber and the olive green mix plus a touch of clear medium, re-state the tree trunk and branches that had already been placed in with the black acrylic at the beginning. Use the chisel edge of a no. 12 badger flat and keep your branches and twigs fairly thin. Don't repaint all the branches—the lighter ones look as if they're at the back of the tree partially hidden by foliage.

Step 7: Tap On Willow Foliage

Begin stroking in the long, thin hanging branches of the willow using a no. 3 fan brush and a sparse amount of olive green or Naples Yellow on the tips of the bristles. Use a very light touch and a downward, skittering, dancing motion of the brush to suggest the long, skinny leaves of a willow. Leave open spaces where the distant background can be seen through the foliage.

Landscape Lesson #10: Let the Background Show Through

Trees and foliage are almost always a major part of any landscape painting. Their importance in establishing depth of field cannot be overstated. As we have learned in this book, the illusion of distance can be created in several ways, such as the change in values and color intensities and the loss of detail as you move into the background. There is one more factor that will help you create depth and distance in your paintings: simply let the background show through your foliage. Trees that are painted as solid shapes almost always look pasted on. Do not overdo the foliage in your foreground trees, no matter what the species. Below are three different types of trees: an airy willow, a dense evergreen, and a deciduous tree. Study each one to see where and how often their foliage is opened up. Not only are their trunks and branches visible, so is the background.

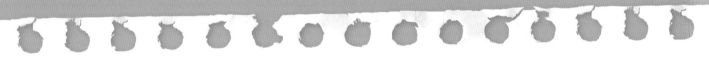

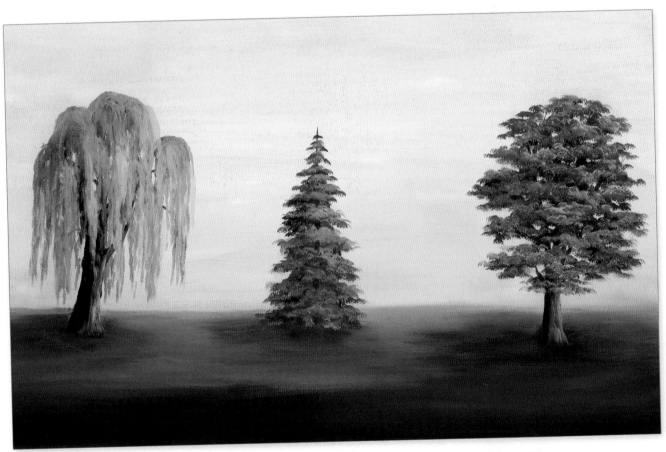

Light, Airy Foliage
- Sky colors show through in several places.
- Small outer branches and twigs are intermittently visible.
- Trunk and main branches can easily be seen.

Dense Evergreen
- Detailed foliage on outer tips of branches shows the sky through and around it.
- Center trunk can be seen in places, even through the densest part of the foliage.

Deciduous Foliage
- Sky shows through in many areas, some large, some very small.
- Outer foliage is very finely detailed and shows up well against the sky.

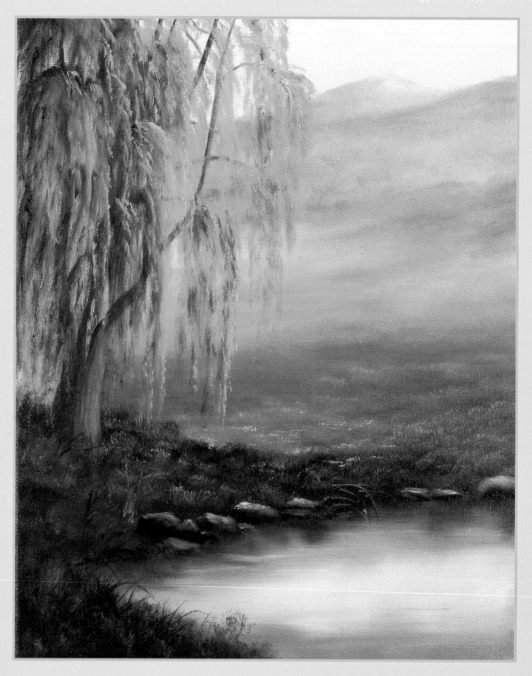

Step 8: Add Tall Grasses, Rocks and Wildflowers

Enrich the colors and strengthen the textures of the grasses on the other side
of the pond using a no. 24 badger flat. Alternate between the light green mix
and Cadmium Yellow Medium. Texturize the grass under the tree with a little
Naples Yellow. Base in the rocks around the water's edge with Ivory Black. Use
peach mix to both highlight the tops of the rocks and to create sharp edges
and planes. As the peach combines with the wet black paint, it becomes
a warm gray. Lightly mop the rocks with a soft mop brush. Use a no. 1 liner
and blue-green mix to pull spiky leaves up from the nearest foreground and
let them curve over the water. Highlight the right side of the willow tree trunk
with vertical strokes of peach. Use the chisel edge of a no. 12 badger flat to
touch on some bright wildflowers under the willow tree with Perinone Orange,
and some yellow ones with Cadmium Yellow Light. Highlight the willow tree
branches here and there with Cadmium Yellow Light for some yellowed leaves.

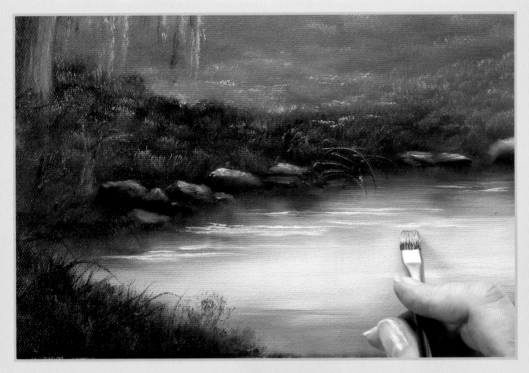

Step 9: Add Ripples in the Water

Using the chisel edge of a no. 10 badger flat, place in the little ripples in the pond with horizontal strokes of Titanium White in the lighter areas of the water, and light blue mix in the shaded areas.

Step 10: Final Touches

Darken the greens of the mid-ground fields to increase the contrast with the willow branches and to set the hills further into the background. Continue filling out the foliage of the willow with highlights of light green and Naples Yellow, but be careful not to close off the open spaces where the sky and background show through. Shade the lower left side of the foreground grasses and where the trunk casts a shadow with blue-green mix and a little Burnt Umber. Lightly tap on little spots of Cadmium Yellow Light in the grass under the tree to brighten this area. Darken the shading under the rocks around the pond's edge with touches of Ivory Black. Place a light green reflection in the pond under the overhanging willow branches.

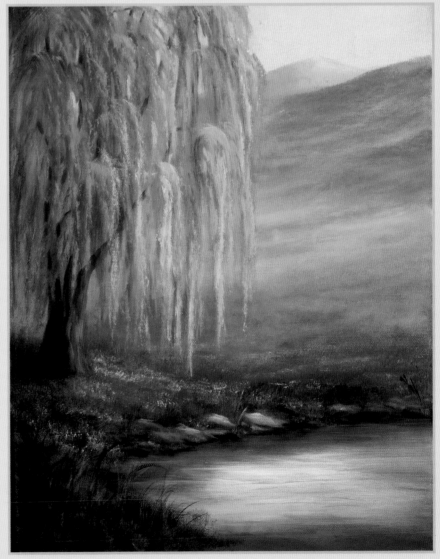

Resources

Index

U.S. RETAILERS

Canvas

Stretched canvases can be purchased at national chain stores such as Michaels, A.C.Moore, Hobby Lobby, Aaron's, etc., and at independent art and craft supply stores.

KG Kanvas Karriers

Kitty Gorrell Studio, Inc.
279 Beech Run Rd.
Friendly, WV 26146
Ph. 304-684-7975
www.KittyGorrell.com

Paints and Brushes:

Permalba Professional Oil Colors, Prima Black Gesso, Liquiglaze Gel, Turpenoid, Alkyd-Gel, Permalba Bristle Brushes:
Martin/F. Weber Co.
2727 Southhampton Rd.
Philadelphia, PA 19154
Ph. 1-215-677-5600
www.weberart.com

DecoArt Americana Acrylics:
DecoArt
P.O. Box 386
Stanford, KY 40484
Ph. 800-367-3047
www.decoart.com

Scharff Classic Filbert and Flat Brushes:
Scharff Brushes, Inc.
P.O. Box 746
Fayetteville, GA 30214
Ph. 1-888-724-2733
www.artbrush.com

Masterson Artist Palette Seal

Masterson Art Products, Inc.
P.O. Box 11301
Phoenix, AZ 85017
Ph. 800-965-2675
www.mastersonart.com

CANADIAN RETAILERS

Crafts Canada
120 North Archibald St.
Thunder Bay, ON P7C 3X8
Tel: 888-482-5978
www.craftscanada.ca

Folk Art Enterprises
P.O. Box 1088
Ridgetown, ON, N0P 2C0
Tel: 800-265-9434

MacPherson Arts & Crafts
91 Queen St. E., P.O. Box 1810
St. Mary's, ON, N4X 1C2
Tel: 800-238-6663
www.macphersoncrafts.com

Permalba Professional Oil Colors, Prima Black Gesso, Liquiglaze Gel, Turpenoid, Alkyd-Gel, Permalba Bristle Brushes:
Martin/F. Weber Co.
26 Beaupre
Mercier, Quebec J6R 2J2
Tel: 866-484-4411

Atmospheric haze, 79
 autumn colors through, 117
 blue mix, 121
 effect on color, contrast, and
 value, 123
 and fog, 108
 mountain through, 82
 trees through, 36

Background
 at bottom of painting, 29
 defining, 59
 forest, 110
 seen through and around tree,
 133, 139
 trees, 34, 36
Barn, mid-ground, 74
Beach, 98
Beads of paint, defined, 14
Black acrylic gesso, basing in with,
 53, 61
Blending
 with badger flat, 27, 61, 109
 with horizontal strokes, 137
 See also Mop brush, blending and
 softening with
Blotting, versus scrubbing, 19
Boulders, 98
Bristles
 bouncing, to create distant trees,
 86
 pushing, to create grasses, 76
Brushes, 10-11
 badger, 27, 61, 109
 fan, 19
 filbert, 16, 18
 flat, neutral stroke with, 18
 loading, 16-17
 mop. *See* Mop brush, blending
 and softening with
Brushstrokes
 bouncing, 97
 on chisel edge, 39, 45-46, 54, 61,
 70, 86-89, 109, 138, 141
 diagonal, 68
 downward, 138
 fanned and curved, 38
 horizontal, 26, 35, 48, 62, 68,
 70-71, 86, 88, 96, 111, 121,
 137, 141
 neutral, 18, 36, 56, 69, 71, 75,
 100-101, 114, 124-129
 painterly, 27, 98, 130
 pushing bristles, 76
 scrubbing in, 100
 short, 98
 steep and angular, 83, 85
 tapping in, 47, 54, 58, 68, 70, 87,
 89, 99, 110-112, 122, 138,
 141
 upward, 54, 138
 vertical, 60, 74, 137, 140
 wavy, 48, 138
Buildings, 74, 88
 See also Outbuilding

Canvas
 applying clear medium to, 20, 25,
 53, 67, 81, 93, 105, 135
 preparing, 12, 25, 53, 67, 93,
 105, 119, 135
Clouds
 blocking in, 106

creating distance with, 26, 29
leveling out to horizon line, 95
size, shape, and value to create
distance, 91, 96-97
Color(s)
adding to clouds, 26
checking against value schematic,
49
controlling temperature and
vibrancy, 51
decreasing, 123
enriching, 69
intense, 26-27, 29
subdued, to create depth, 41, 65
Contrast, 37, 51
Creek, 46

Depth
achieving, from high point of view,
65, 73
beyond what is visible, 41, 44
by subduing colors and minimiz-
ing details, 41
in trees, value changes to indicate,
68
Depth-of-field study, and value
scale, 103, 113
Detail
decreasing, for depth, 31, 41
fading away in distance, 36
foreground and mid-ground versus
background, 65
mid-ground trees, 72
trees, 58, 72, 101
Dirty brush, 88
Distance
creating in sky, 26-29
great, creating illusion, 65, 117
relative, diagram for, 59
See also Background, Depth
Dry brush, removing paint with, 61
Dry-brush effect, 17

Edges
hard, 26
softened through haze, 82
See also Mop brush, blending and
softening with
Evergreens, 72, 109-110, 125
mid-ground, 36-37, 72

Fan brush, 19
"Fat" amount of paint, 17
Fields
distant, 68-69
mid-ground, 70, 111, 136
working forward, 75, 86
Flowers, 49
Foliage
autumn, 56-58, 60-61, 128-129
highlighting, 72
willow, 138
Foreground
bushes, 126
darkening and streaking, 35
defining, 59
field, 86
grasses, 76, 89, 99
mountain, 84
sharply focused, 133
strong colors and sharp details,
117
at top of painting, 29

trees, 36, 39, 79, 100-101, 112,
127
waves, 97

Grasses, 140
finishing with, 39
foreground, 76, 89, 99
textures, 55, 58
Grassy field, working forward, 75
Grays, value scale, 103, 113
Green, range of values in, 41, 44, 49

Haze. See Atmospheric haze
Highlights
additional, 75
boulders, 98
distant, 38, 69
finishing with, 39
foliage, 72
grasses, 97
hills, 109
mid-ground fields, 71
mountains, 84-85
sunny, 103
trees, 56-58, 89, 114, 124-125,
128
Hills, distant, 45, 103, 108-109,
113, 136
Horizon line
creating far distance with, 96
leveling clouds out to, 95

Landscapes
autumn, 50-63, 116-131
editing reference photos for, 21
intimate, 132-141
mountainous valley, 78-89
ocean, 90-101
rolling hills, 102-115
spring, 40-49
sunset, 22-29
valley overlook, 64-77
willow tree, 132-141
winter, 30-39
See also Buildings; Fields;
Grasses; Hills, distant;
Mountains; Ocean; Sky; Tree(s);
Valley; Water
"Lean" amount of paint, 17
Leaves. See Foliage, Tree(s)
Liquiglaze
applying to canvas, 119
to thin green, 48
Loading brush, 16-17

Mediums, 12
clear, applying to canvas, 20, 25,
33, 53, 67, 81, 93, 105, 135
picking up excess, 25
Mid-ground
barn, 74
darker trees, 71
defining, 59
detailing trees, 72
evergreens, 72
fields, 70-71, 111, 136
mountains, 84-85
sunlight and shadows, 133
texture, 38
trees, 36, 47, 55, 70-72, 87, 111
waves, 97
wide range of values, 44
Mop brush, 19

blending and softening with, 34,
45, 54, 69, 77, 86, 95, 107-
108, 120, 122, 129, 140
Mountains
and atmospheric haze, 82
distant, 83, 121
keeping value close to sky, 79,
117
mid-ground, 84

Ocean, 96
Oil paints, characteristics, 15
Orange acrylic underpainting, 12,
25, 53, 61, 67, 93, 105, 119,
135
Outbuilding
distant, 74
graying, to create distance, 77
Overlook, 65, 73

Paint, 10
loading, 16-17
removing, 61
Palette, setting up, 14-15
Path, 91, 99
Photo
black-and-white, for value study,
113
reference, editing, 21
Point of view, high, 65, 73

Reflections
blending, 61
separating from object, 62
sky, 54
softening, 59, 63
water, 54, 137
Relative distance, diagram for, 59
Relative size
and great distance, 65
trees, 82
Resources, 142
Ridgelines, sharp and detailed, 82
Roundness, overlapping color for, 57

Sand, wet, creating with short
strokes, 98
"Scoop" of paint, 17
Scrubbing, 100
versus blotting, 19
Shading
clouds, 107
to recede back, 63
Shadows
deepening, 35
mid-ground, 133
softening values for distance, 44
Silhouettes, shaping and detailing,
125
Size, decreasing, for depth, 31
Sky
basing in, 45, 68
blending, 34
blocking in, 94, 106, 120, 136
creating distance in, 26-29
as landscape, 23
and reflection colors, 54
soft and hazy, 83
See also Clouds
Snowy landscape, 30-39
Supplies, 12-13
resources, 142

Texture(s)
decreasing, for depth, 31
grasses, 97
knocking down, 122
mid-ground snow, 38
minimizing, 34
rough and uneven, 111
softening, 54, 69, 77, 86, 129
stiff bristle brush for, 48
Tree(s)
detail, 58
distant, 34, 54, 59, 68
establishing value scale, 103
foreground, 39, 79, 100-101,
127
grove, 48
lightening bark on, 62
mid-ground, 47, 55, 72, 87
rust-colored, 124
seeing background through, 133,
139
sharp focus, 59
trunks, 34, 53, 138
in valley, 121
variation in size and detail, 51
willow, 133
See also Evergreens, Foliage
Treeline
background, 69
distant, 44-45
V-shaped, 73
Twigs, 39

Underpainting, 12, 25, 53, 61, 67,
93, 105, 119, 135

Valley, 108
overlooking, 65, 73
trees in, 121
Value(s)
blocking in darkest, 33
checking, 49
deepening, 27-28
decreasing, to create distance,
31, 65, 123
distant objects, 36
full range, 41
importance of in creating dis-
tance, 44
lightest, 34
sky and mountain, keeping
similar, 79, 117
Value scale, grays, 103, 113
Value schematic, 44
Value study, for great distance, 73

Water
blocking in ocean, 96
reflected colors, 51
reflections, 54, 59-60, 137
ripples, 48, 62, 141
See also Creek, Ocean, Waves
Waves
adding, 62
distant, mid-range, and fore-
ground, 97
size and shape, to create dis-
tance, 91, 96-97

The best in painting instruction & inspiration is from North Light Books!

Want to paint gorgeous florals and dramatic landscapes on canvas in less than three hours? Professional artist Terrence Tse shows you how to put all the joy back into painting with his fun and unique sponge-painting techniques. His secret? He uses regular acrylic paints and a common household sponge! In this full-color, step-by-step book, you can choose from 20 start-to-finish painting demonstrations and create your own masterpiece in as little as 90 minutes. You'll learn how to use a sponge to paint everything from orchids, lilies and tulips to palm trees, bamboo and cherry blossoms; from moonlit lakes and reflective rivers to poppy-strewn fields, misty mountains and an early morning sunrise. No brushes—and no experience—needed!

ISBN-13: 978-1-58180-962-6, ISBN-10: 1-58180-962-X, paperback, 128 pages, #Z0686

Capture the rich, illusive properties of light! In 10 step-by-step demos, beloved artist Dorothy Dent shares her easy-to-master techniques for painting light-filled landscapes in different seasons, weather conditions and times of day. Dorothy includes oil and acrylic painting demos, with advice for adapting the technique used for one medium to that of the other. Prepare to be amazed by the landscapes you create!

ISBN-13: 978-1-58180-736-3, ISBN-10: 1-58180-736-8, paperback, 144 pages, #33412

When you're in a hurry for painting help, here's the book to turn to for ideas, instruction and inspiration. With more than 40 step-by-step demonstrations by 26 top artists, such as Claudia Nice, Lian Zhen, Kerry Trout and Hugh Greer, *Painter's Quick Reference: Landscapes* shows you how to paint all the major landscape elements, including clouds, mountains, trees, water and much more. Use this special guide to jumpstart your creativity, learn painting techniques or explore new mediums—including acrylics, watercolor and oils. With ideas for difference seasons, times of day and weather conditions, this is the perfect creative boost for any landscape artist!

ISBN-13: 978-1-58180-814-8, ISBN-10: 1-58180-814-3, paperback, 128 pages, #33495

Painting water effects can be a challenging task for any artist. This book allows everyone—from those taking their first "plunge" to seasoned painters—to create light-filled water scenes in a matter of hours! Renowned artist and nationally televised teacher Robert Warren shares his own "special secrets" for capturing crashing waves and placid lake reflections by starting with an acrylic underpainting and finishing with oils. Includes 12 complete step-by-step demonstrations that show you how to paint water in all its forms and in all seasons, including ocean waves, rushing streams, waterfalls and cascades, quiet reflective lakes, woodland creeks, and so much more.

ISBN-13: 978-1-58180-851-3, ISBN-10: 1-58180-851-8, paperback, 128 pages, #Z0054

These books and other fine North Light titles are available at your local art or craft retailer, bookstore or online supplier, or visit our website at www.mycraftivity.com.

Prepare your students with the power of classroom practice

adopt and assign
MyEducationLab today
www.myeducationlab.com

What is MyEducationLab?

MyEducationLab is a powerful online tool that provides students with assignments and activities set in the context of real classrooms. MyEducationLab is fully integrated in your text and provides practice for your students in an easy to assign format.

PRACTICE TESTS: These self-paced assessments give students an opportunity to test their knowledge of chapter content. Based on a student's performance on the test, MyEducationLab generates an individual study plan to help each student identify topics for which he or she needs additional study. MyEducationLab then provides the appropriate chapter excerpts and, in some instances, interactive, multimedia activities to help the student master that content.

ASSIGNMENTS AND IN-CLASS ACTIVITIES: Each chapter in MyEducationLab includes assignable Activities and Applications exercises that use authentic classroom video, teacher and student artifacts, or case studies to help students understand course content more deeply and to practice applying that content.

PRACTICE TEACHING: Building Teaching Skills and Dispositions exercises use video, artifacts, and/or case studies to help your students truly see and understand how specific teaching techniques and behaviors impact learners and learning environments. These exercises give your students practice in developing the skills and dispositions that are essential to quality teaching.

Does it work?

A survey of student users from across the country tells us that it does!

93% MyEducationLab was easy to use.

70% MyEducationLab's video clips helped me to get a better sense of real classrooms.

79% I would recommend my instructor continue using MyEducationLab.

Percentage of respondents who agree or strongly agree.

Where is it?

- Online at www.myeducationlab.com
- Integrated right into this text! Look for margin annotations and end-of-chapter activities throughout the book.

What do I have to do to use MyEducationLab in my course?

Just contact your Pearson sales representative and tell him/her that you'd like to use MyEducationLab with this text next semester. Your representative will work with your bookstore to ensure that your students receive access with their books.

What if I need help?

We've got you covered 24/7. Your Pearson sales representative offers training in using MyEducationLab for you and your students. There is also a wealth of helpful information on the site, under "Tours and Training" and "Support." And technical support is available 24 hours a day, seven days a week, at http://247pearsoned.custhelp.com.